Oxnard

SUGAR BEETS

VENTURA COUNTY'S LOST CASH CROP

Jeffrey Wayne Maulhardt

THE
History
PRESS

Published by The History Press
Charleston, SC
www.historypress.net

Front cover, clockwise from top left: Fred Noble, sugar beet field, Oxnard brothers, Oxnard Sugar Factory. *Back cover*: Factory workers, sugar factory interior, Wendell Daily. *Author's collection.*

First published 2016

ISBN 9781540200549

Library of Congress Control Number: 2016941442

To my group of history supporters and local historians who have supported me with information, leads and encouragement in this project and in all my history projects: Frank Naumann, Chuck Covarrubias, Jim Gill, Wayne Huff and my wife, Debbie Maulhardt.

CONTENTS

ACKNOWLEDGEMENTS

Thanks to the many people who have helped me over the years, collecting the pictures, stories and information used for this book. My great-uncle and aunt, Richard and Ruth Maulhardt, were the first to guide and educate me over twenty-five years ago. All of my extended aunts and uncles and distant cousins from the Maulhardt and Borchard families have also been generous with their time and support.

Additionally, I want to acknowledge the descendants of the Oxnard family, starting with James and Thornton Oxnard, who allowed me access to their family archives. More recently, Tom Oxnard came to visit Oxnard, and he, too, shared his stories and articles.

INTRODUCTION

The sugar beet was the crop that transformed the agriculture of Ventura County from a break-even venture to a lucrative cash crop for the farmers. Previously, cattle and sheep grazing had failed for many due to reoccurring drought years. Dry farming crops like barley, wheat and alfalfa were a safe investment, but profits were low, and as in the case of livestock, vast acreage was needed in order to turn a profit. Farmers experimented with other crops such as potatoes and lima beans, and while lima beans thrived along the coastal plain, the big cash crop was still elusive to the early farmers. Drilling for water wells was expensive and thus needed a crop that would guarantee a profit. Along came sugar beets, and once it was established that they could thrive in the soils of Ventura County, land values went up and a new population was needed to service the crop.

This is the story of how sugar beets came to the United States and made their way west to Ventura County. Also told is the history of the Oxnard family and how they developed the beet sugar industry as an alternative to cane sugar, thus making sugar one of the county's leading commodities.

Finally, this is about the many people who had a hand in the creation of a city that was named for the family who brought a factory to Ventura County.

For the city of Oxnard, the introduction of sugar beets created a home for many immigrant groups who have contributed to the agricultural industry. While sugar beets have long since grown in the alluvial soils of the Oxnard

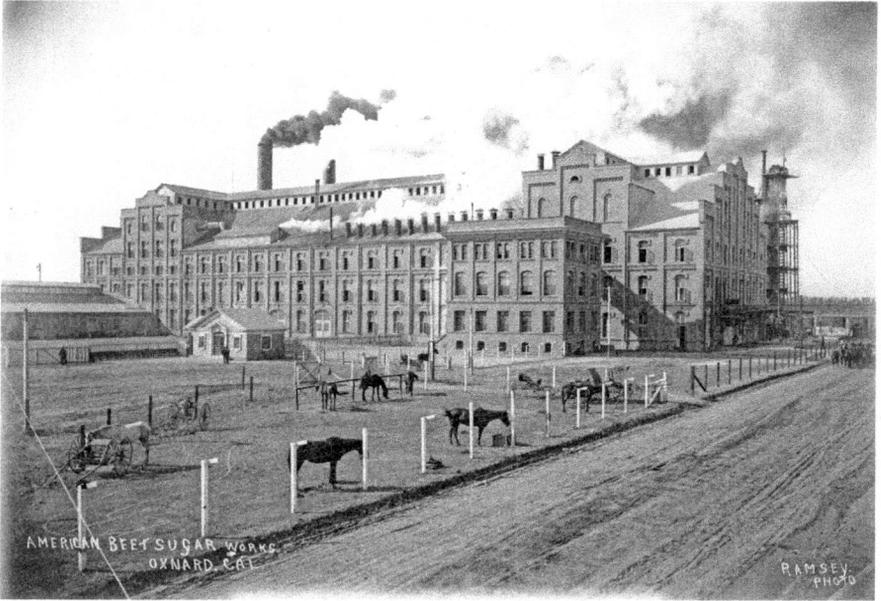

The American Beet Factory was located near Wooley Road and Oxnard Boulevard and was, for a short time, listed as the largest sugar refinery in the world. *Author's collection.*

plain, their introduction to the community laid the foundation for the largest city in Ventura County. Many cash crops have followed the sugar beet, as farmers continue their search to find a way to make the most of the area's rich soil.

EARLY AGRICULTURE

Commercial agriculture in Ventura County did not begin until the late 1860s. The Chumash provided the backbone during the mission period and into the rancho expansion time. The rancho that became Oxnard, Hueneme and parts of Camarillo was *El Rio de Santa Clara o la Colonia*, translated as "the Colony by the Santa Clara River." It was forty-four thousand acres that were granted to eight soldiers from the presidio in Santa Barbara after 1837. They included Rafael Gonzalez, his brother Leandro, Valentin Cota, Salvador Valenzuela, Jose Maria Valenzuela, Vicente Pico, Rafael Valdez and Vicente Feliz. Few of the petitioners for the rancho settled on the remote section of land that was cut off by the Santa Clara River to the north, the Pacific Ocean to the west and the Santa Monica Mountains to the south. After years of litigation, the Gonzales family ran cattle on their portion near the river bottom. By the 1850s, the sparsely populated ranchos had survived through hospitality, trade and contributions from the native people.

Agriculture was still a personal endeavor in the area. The cattle industry lived and died with the varying levels of precipitation, and the final blow came during the drought years of 1863–64. Thousands of cattle perished due to a lack of grasslands. The *Ventura Signal* wrote in an 1872 article that sixty thousand head of cattle died, and many more were slaughtered. Many of the original land grantees were forced to sell the lands they had originally retained when California joined the Union in 1850. Squatters began looking for government land to homestead. Thomas Scott purchased many of the ranchos in anticipation of a thriving oil industry

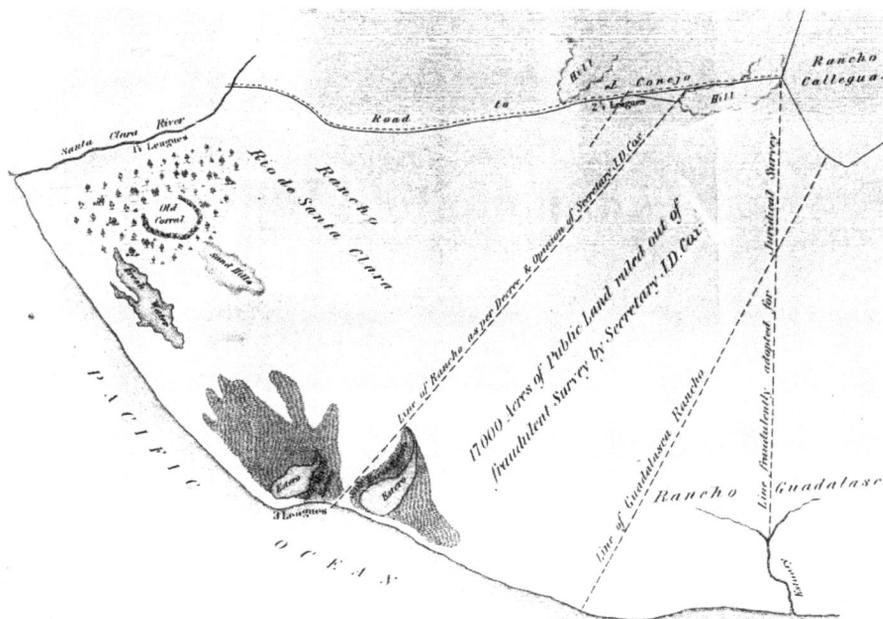

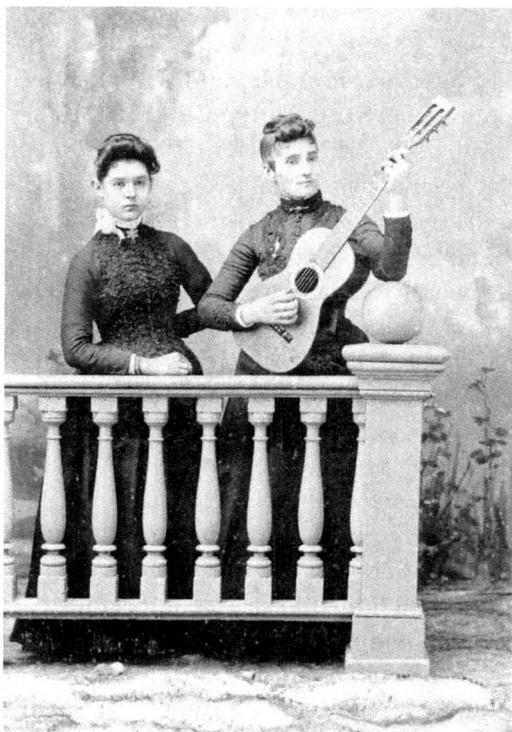

Above: Early map of El Rio de Santa Clara o la Colonia that shows the location of the Gonzalez corral, as well as the seventeen thousand acres of disputed land that were later settled in favor of Thomas Bard. *Author's collection.*

Left: This lady with a guitar may be a descendant of the Gonzalez family, the original grantees of the El Rio de Santa Clara o la Colonia. Several of the Gonzalez family members were musicians. *Courtesy of Paula Eastwood, descendant of the Gonzalez family.*

after he became aware of some reports from Benjamin Silliman following a visit to Ojai and the Ventura area in 1864, during which he witnessed "rivers" of oil. However, reaching the buried reserves proved frustrating to several supervisors, including Thomas Bard, who came to Ventura from Pennsylvania in 1865. After nearly two years of little progress in drilling for the big payday, Bard was ready to return to Pennsylvania and even sent a rider to Los Angeles with a telegram of resignation on December 8, 1866. His resignation would take effect on January 10, 1867. However, Scott did not acknowledge Bard's letter, and Bard continued with his oil duties through February.

In March 1867, something occurred that changed the direction of commerce for many years to come. German-born Christian Borchard traveled to the gold fields of Northern California before settling in the San Joaquin Valley to farm and raise stock. After the floods of 1866 wiped out his livelihood, he traveled south and ended up on the south side of the Santa Clara River. He and his son John Edward Borchard planted thirty acres of barley and thirty acres of wheat, only to realize the wheat was susceptible to rust while the barley flourished. His initial crop set the stage for the evolution of the land and the growth of agriculture on what would become the Oxnard Plain.

Meanwhile, Thomas Bard reiterated to Thomas Scott in another letter in April 1867 that he was determined to return home to Pennsylvania. Then he met with Captain W.E. Greenwell of the Coast and Geodetic Survey, and the two camped out together for a few days. Greenwell pointed out to Bard the desirable qualities of the area that would become Point Hueneme for a wharf site. Soon after, Thomas Bard withdrew his resignation request and began plans to build a wharf near the former Chumash resting ground, near Wynema, to accommodate his

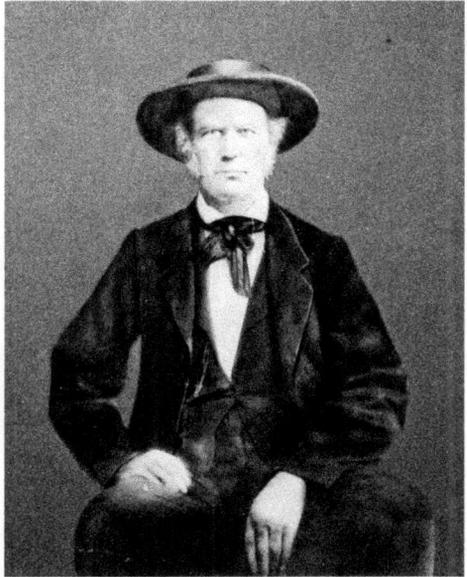

The only known picture of Christian Borchard, who arrived in the area in 1867 and, along with his son John Edward Borchard, planted the first commercial crop on the Oxnard Plain. *Author's collection.*

next venture of subdividing the large ranchos into smaller ranches.

Christian Borchard sold his Northern California holdings and, on October 28, 1867, paid $3,200 for one thousand acres of the uncultivated land on the south side of the flowing Santa Clara River known as El Rio de Santa Clara o la Colonia. He purchased the land from Jose Lobero, who was married to Maria Clara Cota, daughter of Valentin Cota, one of the original grantees of Rancho Colonia. However, Lobero purchased his Colonia land from another original grantee, Rafael Gonzalez, one of only two of the eight to live in the rancho. (Rafael's brother,

Top: Thomas Bard was hired by Thomas Scott to supervise the development of the oil industry on his Ojai and Santa Paula land, but eventually Bard became the real estate broker for the ranches of the Oxnard Plain. *Author's collection.*

Left: Thomas Scott, who bought up several of the original ranchos of Ventura County, including the majority of El Rio de Santa Clara o la Colonia. *Author's collection.*

Leandro, also built an adobe and lived on the rancho for a brief period.) Christian Borchard and his family stayed in Rafael's "adobe Viejo" until they could build a wooden structure. The first wood-frame home was built by James Leonard, who bought an adjoining one thousand acres to the west of Borchard and also purchased land from Lobero in the spring of 1868.

Bard's first sale went to Michael Kaufmann on November 2, 1868, for 160 acres. Kaufman's five daughters were as big an asset as his newly acquired acreage. Each would marry into a prominent farming family, uniting hundreds of cousins for decades to come. Among the families the Kaufman sisters married into were the Borchards (John Edward married Mary Kaufman), the Hartmans (Fridolyn married Kathryn Kaufman), the Petits (Justin married Frances Kaufman) and the Pfeilers (Louis married Carolyn Kaufman). A fifth daughter, Lizzie, was estranged from the family after an altercation with her mother and the girl's abrupt marriage to the Kaufmans' foreman, Joseph King.

Bard's biggest sale was to J.D. Patterson from New York. Patterson purchased nearly six thousand acres for grazing purposes, as well as barley production. Among the early ranch hands to work at the Patterson Ranch

The James Leonard home was the first wood-frame residence on the Oxnard Plain, built in 1868 and torn down in 2005. *Author's collection.*

Above: Michael and Mary Kaufman. The Kaufmans' daughters married into many of the first families of Oxnard, including the Borchards, Hartmans, Petits and Pfeilers. *Author's collection.*

Left: Charles J. Daily worked as the foreman of the Patterson ranch before farming in Camarillo, where he later patented over forty varieties of avocados. *Author's collection.*

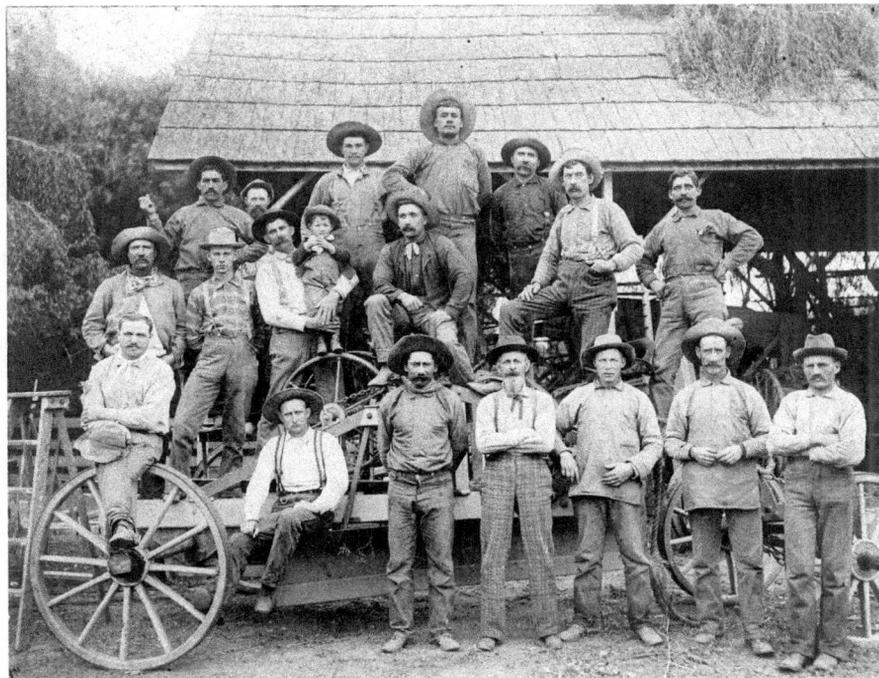

Workers from the Patterson ranch, circa 1890s. This rare image includes members of the Eastwood and Daily families. *Author's collection.*

were Charles J. Daily; his brother, Wendell; and their father, Charles Wesley Daily. The Dailys eventually purchased several acres in Camarillo, where they became innovative farmers and community leaders.

Also working at the Patterson Ranch were George and Hubert Eastwood, each earning thirty-five dollars a month. Hubert eventually entered public service as a council member in 1909, and by 1920, he had become the mayor of Oxnard.

Other early farmers who purchased acreage from Bard in 1869 included Jacob Gries and James Saviers, who bought 682 acres at $15.00 an acre; Peter Donlon, who bought 533 acres at $13.25 an acre; and William I. Rice, who paid $13.50 an acre for 1,762 acres.

Many of the early farmers leased their land before they had enough money to purchase it. This was the case for Jacob and Gottfried Maulhardt and Johannes Borchard. The Maulhardt brothers traveled from Germany in 1867 to escape the Prussian Wars and joined Christian Borchard in California. When Borchard was flooded out of his Contra Costa land in

1866, the group traveled to the unfarmed land of what would become the Oxnard Plain. They leased 1,200 acres from Juan Camarillo, and by December 23, 1872, while the land was still part of the soon-to-be-partitioned Santa Barbara County, the three immigrants had paid $12,310—or $10 an acre—to Camarillo.

These first farmers grew mostly barley and corn, with many of the larger ranches raising sheep and hogs. However, wild mustard covered the uncultivated land. Christian Borchard took full advantage of the invasive plant. There are several theories on how the black mustard was introduced to Southern California. The most common belief is that Franciscan friars spread the seed to mark the trails that became the El Camino Real. Many of the trails date back to the Chumash, who traveled them for centuries. Another theory on how the plant was propagated was from the importation of sheep and cattle, which carried the seed in their fur or stuck to their hides.

The site of the wild mustard plant rising six feet in the air and covering miles of uncultivated land was an encouraging sign for the first farmers looking to plant new life. After modifying a Mayberry grain header, Christian Borchard harvested 25 tons of wild mustard plant at two cents a pound. In 1870, he produced 5,710 sacks that weighed 265 tons and gave him a profit of $1,075. This bumped him into the top ten producers listed in the *Products of Industry in Ventura County*.

In the spring of 1878, the *Ventura Free Press* published a series of articles that chronicled the location of all the ranches in Ventura County. The *Ventura Signal* answered with its own report the following January. These two were combined for a quarterly publication by the Ventura County Museum of History & Art in 2002. Culled from these pages, the following information shows the condition of agriculture in the 1870s.

For Ventura County in 1878, there were 39,710 acres planted to barley; 15,596 acres to corn; and 5,671 acres to wheat. Also present on many farms were livestock, including 8,250 hogs in the west county alone. Sheep were also abundant. The Patterson Ranch had 2,500; Henry Arnold had 1,100; Thomas Rice and Jack Hill raised 2,076; Christian Borchard had 1,000; Doolittle, Metcalf & Co. raised 5,000 on a large portion of the Guadalasca Rancho they leased from William Broome; Henry Arnold, on the Conejo, had 1,100; Johannes Borchard had 1,000; the Arnolds had 1,100; H.W. Mills had 1,200; and Blanchard and Bradley had 2,000 sheep.

The *Ventura Signal* series of articles was much more detailed and showed a growth of activity in the eight months since its rival paper's publication. The livestock count was growing, with 24,000 head of hogs; 55,000 sheep; 1,000

Wild mustard plants cover the plain. *Author's collection.*

Angora goats; 2,000 horses; and 1,400 cattle. Dominick McGrath added 1,200 sheep to his river-bordering land, as did John Scarlett, who added 1,500 head of sheep.

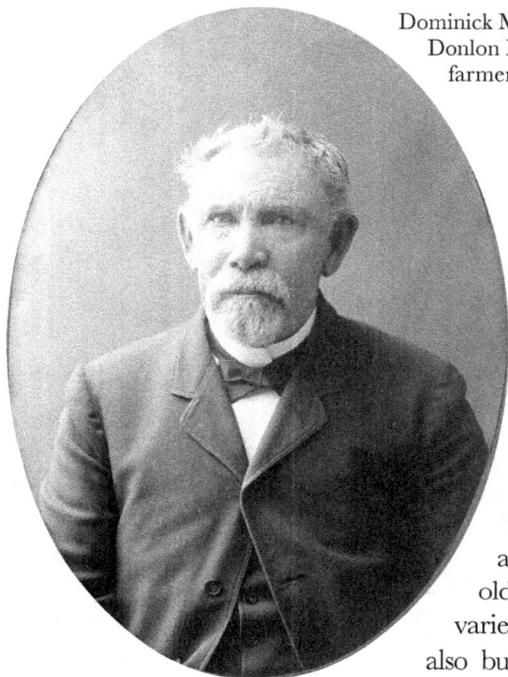

Dominick McGrath, along with his wife, Bridget Donlon McGrath, was among the earliest farmers to the area. *Author's collection.*

Humble beginnings were something else these articles pointed out. Jacob Maulhardt's "model ranch" was described to include 240 acres of barley, 25 acres of corn, fifty tons of pumpkins, fifty head of hogs, two hundred chickens, thirty-eight horses and geese, plus 3 acres of fruit trees and a two-year-old vineyard with 1 acre of a choice variety of imported grapevines. He also built a home at a cost of $3,000 that contained a fifteen- by twenty-four-foot dancing hall. The writer concludes: "Our purpose in thus going into details is to illustrate what may be done in Ventura County by a little pluck and well directed energy; a few years ago Mr. Maulhardt came here with a wife and three children and not a cent in his pocket; he rented the land the first year at fifty cents per acre and went to work; next he bought 400 acres, paying $10 an acre."

Other examples of the early farm work were recorded in a ledger kept by John Edward Borchard, who worked with his father, Christian Borchard. The younger Borchard was born in Iowa in 1847, shortly before his father headed for the gold mines of California. He had little opportunity to get any formal schooling due to his family's frequent travels, yet he kept a ledger with names of the first farmworkers in the area and how much they were paid. Some of the names included: "mikel kaufman" (Micahael Kaufman), "james lenart" (James Leonard), "gotfreat moulhart" (Gottfried Maulhardt) and "jabop moulhart" (Jacob Maulhardt). Others who appeared in the ledger were "wilyam suttor, oliver whitton, august huihting, tommas morcel, gimmy and big mack." Who these names refer to is anyone's guess.

Most of the workers appeared to be paid for cutting barley: "Jackop cut 95 ackors [acres] for $189.70 and another 9.75 for stacking. Sutter cut 53½

John Edward Borchard's ledger from 1872, showing the record of work done on the Borchard ranch. *Author's collection.*

ackors for $80.25 and gotfreat cut 54 ½ for $81.75 while james leanart cut 160 ackors for $320."

Borchard also loaned $100 to "whan camarilo" (Juan Camarillo).

On September 27, 1872, John Edward Borchard noted that "gilbert" (George Gilbert) from the Wynema wharf bought one thousand sacks of barley at eighty-five cents a sack and another thousand at eighty-two and

a half cents, totaling $1,675. Using an online Morgan Friedman inflation calculator, that would be equivalent to nearly $35,000 in today's terms.

A few years later, in 1879, Borchard recorded a few more transactions that link even more early pioneers to the area. He paid "james donlan" (James Donlon) and "archy conlay" (Archie Connelly) $104.00; "filer" (Louis Pfeiler), $2.00 a day; Caspar Borchard (a cousin—spelled correctly!), $200.00 "A moulhart" (Anton Maulhardt), $157.00; Wolf & Levy (merchants from Wynema), $244.88; and "Chynams" (Chinaman?), $151.00.

Referring to previously mentioned 1878 and 1879 articles, the names of the first generation of farmers whose families continued farming in the county for several generations included Dominick McGrath, who was ranching seven hundred acres at the time and would add several more ranches over the years to give the family the distinction of being the longest continuously farming family in the Oxnard area, next to the Maulhardt family. Back in 1879, Dominick had three hundred acres in barely at twenty sacks an acre, with the balance in grazing land. He had 1,200 head of sheep, twenty American horses, three hundred hogs, 20 head of cattle and a twenty-five- by forty-foot barn.

James Leonard farmed 1,000 acres, and his ranch contained an immense barn of forty by seventy-five feet, a granary and seven buildings, which the paper described as having "more of the resemblance of a village than the home of a quiet farmer." Leonard had 700 acres in cultivation and threshed nine thousand sacks of barely from 450 acres, with 80 acres in corn, one hundred head of hogs, thirty head of cattle and forty good horses.

Mark McLoughlin farmed 350 acres, with 160 acres in barley, producing two thousand sacks; 20 acres of corn; seventy-five hogs; fifteen head of cattle; and one hundred tress of different varieties of fruit.

Peter Donlon had three hundred acres in barley, twenty acres in alfalfa, fifty acres in corn for his three hundred hogs, sixteen horses, a sixteen- by forty-foot granary, a forty- by eighty-foot barn and a two-story house with a balcony running around the second story.

Thomas Cloyne farmed 180 acres in barley and rented an additional 120 acres from Hollister for barley and 20 acres for corn for his one hundred hogs. He also had 1,400 head of fine stock, most likely sheep. He built a thirty-two- by sixty-four-foot barn.

Thomas Rice farmed 470 acres in barley and another 900 acres with John Hill. He also had 150 in corn, twelve Morgan horses and an additional one hundred horses and 2,500 head of sheep in partnership with Hill.

Johannes (John) Borchard, cousin to John Edward Borchard and brother to Caspar Borchard, came over in 1871 from Werxhausen, Germany. He

traveled with his wife and two sons, only to lose his six-year-old after a rough Atlantic Ocean crossing and then burying his nine-month-old upon his arrival in the area. Yet he went on to donate the land for the original St. John's Hospital in Oxnard, along with a donation of $20,000 to help build the hospital in 1914. Back in 1879, John farmed four hundred acres that produced 3,669 sacks of barley and supported 1,300 sheep.

His neighbor to the north was Gottfried Maulhardt, who sold two hundred acres of his four-hundred-acre ranch to Caspar Borchard yet was able to plant the majority in barley at twenty sacks an acre. His cottage house is the only remaining house from this time period and was described as follows: "His neat little cottage house is hid away

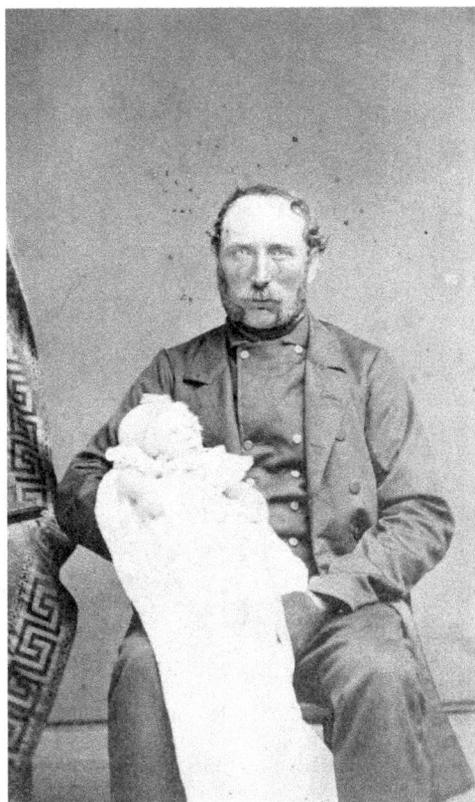

Top: Charles Donlon was the son of Peter Donlon and Katherine Cloyne Donlon, who left Ireland during the potato famine of the 1840s and eventually made their way to Dublin, California, before relocating to the Oxnard Plain. *Author's collection.*

Right: Johannes Borchard traveled from his native country of Germany in 1871 with his wife and two sons. Both sons died before reaching the West Coast, where he raised three daughters who married into the Fasshauer, Friedrich and Maulhardt families. *Author's collection.*

among acacias and other ornamental trees and flowers. An abundance of water is raised by an Althouse windmill. It carried up into a 4000 gallon tank, 30 feet high." Also included in the description is another connection to the history of the area. Many of the early farmers were of Catholic faith and attended the mission church in Ventura. Due to the long ride and the hazards associated with crossing the bridgeless Santa Clara River to get there, the growing farming community to the south of the river banded together to build a Catholic church. Gottfried, along with his brothers Jacob and Anton, Christian Borchard and Dominick McGrath, formed the building committee to get the project accomplished. To accommodate the church services, Gottfried Maulhardt erected a brick building on his property to serve as a winery. A January 11, 1879 *Ventura Signal* article confirmed Gottfried's association with the winery when it published the following sentence in the same article: "A small vineyard of 250 grapevines of the choicest varieties."

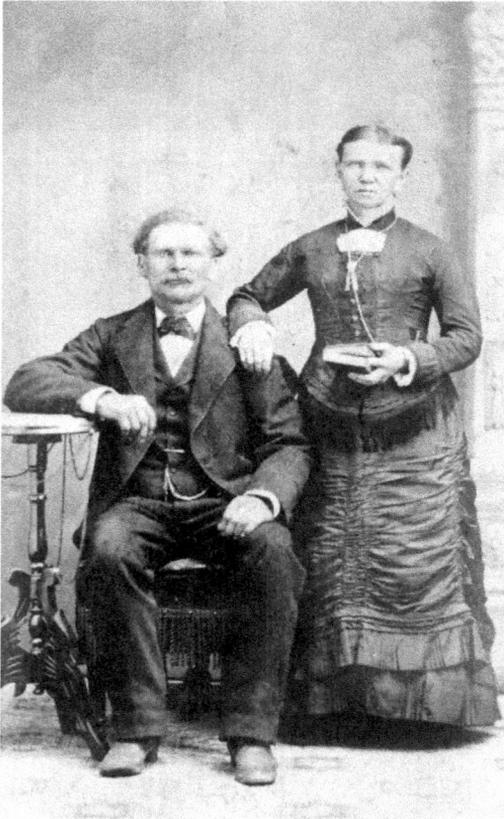

Gottfried and Sophie Maulhardt, circa 1880s. He grew grapes and constructed a brick winery building in the 1870s that survives today as part of the Oxnard Historic Farm Park. *Author's collection.*

Though the vineyards did not survive into the twenty-first century, the winery and the house both have. They have become part of the Oxnard Historic Farm Park that was given the address 1251 Gottfried Place, Oxnard. To connect the winery with the past, the foundation for the Farm Park secured cuttings for the vineyards from Santa Cruz Island, one of the eight Channel Islands off the nearby coast that date back to the 1880s.

While barley remained a staple crop for the early farmers, they were always on

The pass on the Lewis Grade, between Newbury Park and the grade toward the Oxnard Plain, behind the current University of California–Channel Islands. *Author's collection.*

the lookout for a crop that would bring in more income. The introduction of lima beans to Ventura County started a long relationship with that crop.

The story of the lima bean in California begins in 1855, when the seed was first advertised by the H. McNally Company in the Northern California newspaper *Alta*. In 1859, an article appeared in the magazine *California Culturist*, and the author encouraged the planting of lima beans for vegetable gardens. A decade later, in the late 1860s, Robert McAlister was farming forty acres in Carpenteria. In 1872, he came across a bean that would change the agriculture of portions of Southern California. There are two stories of how he came across the influential crop. One story claims he was meeting his brother, who arrived on a ship that was docked in the Santa Barbara Harbor, and McAlister was invited to have a meal aboard an anchored vessel traveling from Chile to San Francisco. The second story substitutes his brother for an old acquaintance. From here, the story merges. Though the bean is native to Guatemala, it was in the port of Callao, Peru, and its surrounding hillsides that the plant thrived, and this is where the cook obtained his quantity. After enjoying a meal with the crew, McAlister obtained a "hatful" of the large bean.

Joseph Lewis brought the lima bean to Ventura County. *Author's collection.*

The soil and climate in Ventura County proved friendly to the plant. After perfecting the cultivation of the bean, McAlister named the legume "lima bean," in reference to its place of origin. He planted the seeds in his garden without staking up the plant or establishing irrigation, and he produced a bumper crop. He shared the seeds with other farmers, including Henry Fish and Henry Lewis, who farmed on the hillsides of Carpenteria, near the ocean. Lewis perfected a strand that he marketed in Ventura County with Frank Barnard as the Lewis common lima. He rented 260 acres near Camarillo in 1889. The following year, he leased 300 acres in Montalvo for a ten-year period before returning to Camarillo in 1901 to plant a large portion of the Adolfo Camarillo ranch in lima beans. By 1906, he had purchased over 8,000 acres, which Joseph Lewis continued to farm for the next several decades.

Another Lewis, William Leachman Lewis—of no relation and, later, the mayor of Ventura—is said to have planted lima beans on land near Santa Paula in the early part of the 1880s. Several farmers in the Montalvo and Ventura areas, including George Faulkner, also experimented with growing lima beans. Leachman Lewis became encouraged by the success of his crop and is said to have leased part of the Scarlett ranch, next to the McGrath ranch, to grow beans on the Colonia Rancho. Here, Leachman Lewis planted the first commercially grown lima beans on the south side of the Santa Clara River.[1]

Up to this time in the 1880s, barley, corn and wheat had been the major crops in the county. Achille Levy, a produce broker in Hueneme, was a member of the San Francisco Produce Exchange and had a respectable knowledge of the market value of produce. Levy received word from his connections in the Midwest that a new strain of barley was being developed and the market value of barley would decrease. Levy was known to spend up

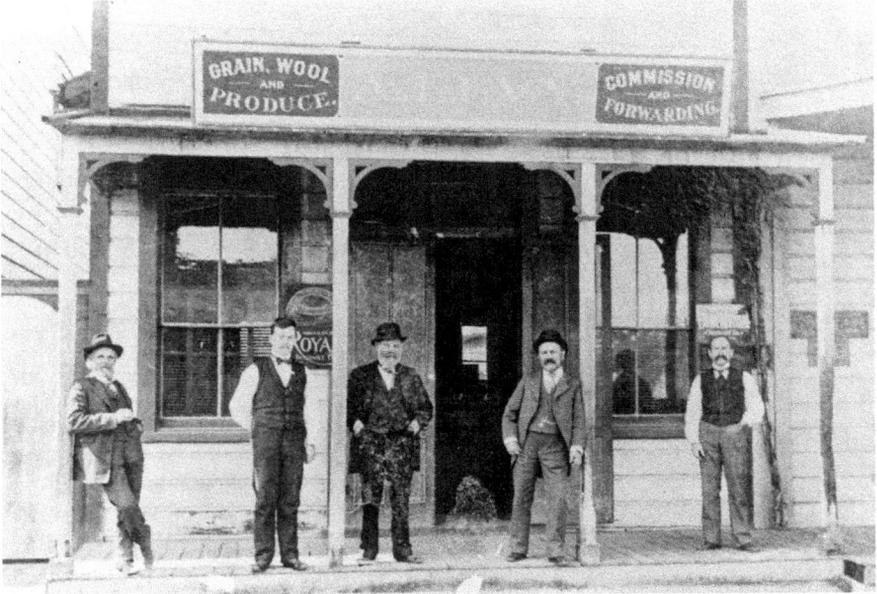

Achille Levy operated a brokerage business in Hueneme and was instrumental in transporting lima beans to the East Coast. *Courtesy Hueneme Historical Society.*

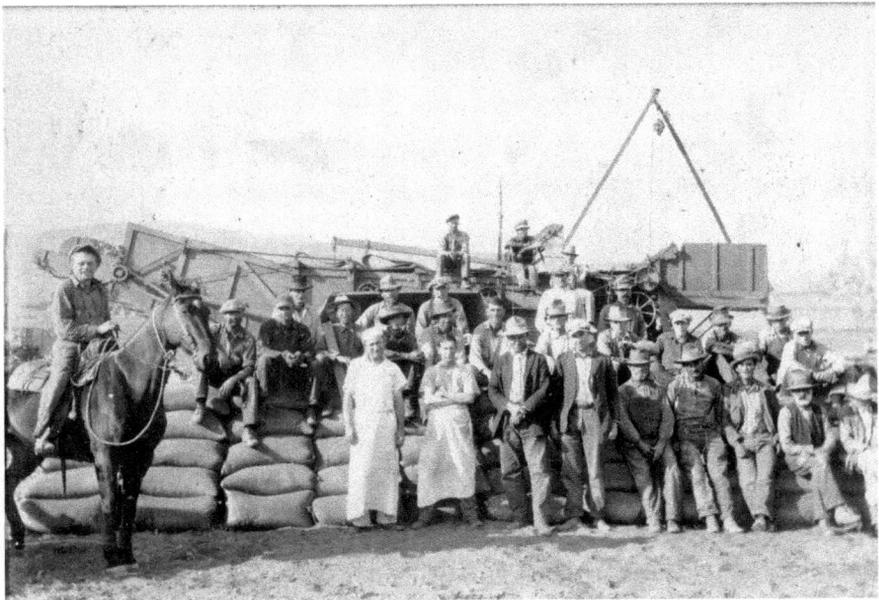

The Waters bean-threshing outfit. *Courtesy Chuck Covarrubias.*

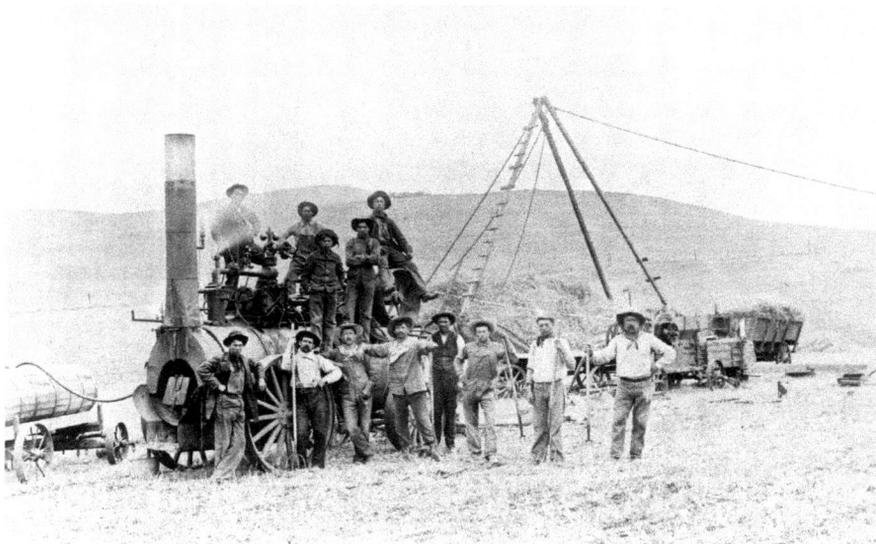

Louis Maulhardt's bean-threshing crew, circa 1910. Many of the workers were of Portuguese origin, including Frank Dutra, Francis Durate, John Domingos and Bill Rogers. *Author's collection.*

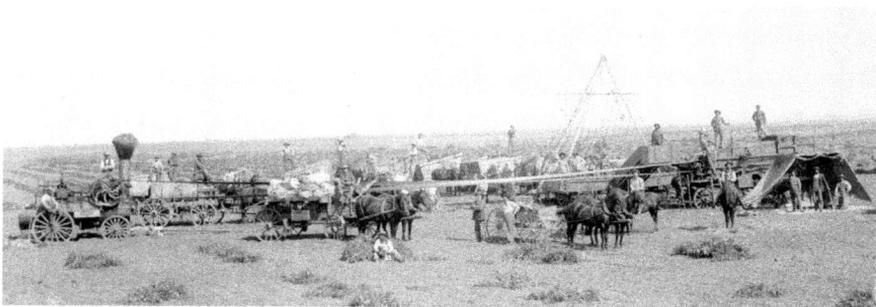

Threshing lima beans on the Patterson ranch, circa 1890s. *Author's collection.*

to $200 on Western Union communications to stay on top of the market.[2] News of the certain drop in barley prices alerted Levy to keep his eye on a replacement crop.

Levy soon placed an ad in the local paper promoting the sale of the beans for planting. By 1887, close to six thousand acres were planted in beans, resulting in 4,500 tons, or 140,000 bags. In 1890, Levy sent twenty-two freight cars from San Pedro to the eastern cities. The cars carried a message from the future lima bean capital. Hanging from the cars were large signs

that read, "Beans from A. Levy, Hueneme, California." Thus, Achille Levy earned the title of the "Bean King," and soon the Oxnard Plain earned the reputation of being the Lima Bean Capital of the World.

However, by 1895, most farmers had dedicated their land to lima beans. Albert F. Maulhardt, along with Jacob Maulhardt, M. Cannon, D. Lewis, H.F. Clark, P.S. Carr, T.G. Gabbert and J.E. Borchard, all joined together to form a Lima Bean Association in October 1896. With an overproduction of the crop, prices for the lima bean were falling fast. The price of lima beans dropped from five cents per pound in 1890 to two and a half cents in 1895.[3] The estimated losses for 1895 were over $1 million.

The county was ripe for a new cash crop.

THE HISTORY OF SUGAR

S ugar cane was mentioned as far back as the third century BC by the Greek writer Theophrastus, who referred to it as "honey from bamboos."[4] Centuries later, it was found in Persia, where it was carried westward. In North America, the first sugar mill was constructed under the leadership of Hernando Cortez in Mexico in 1553. The mill produced sugar for the next four hundred years.[5]

The origin of the sugar beet (*Beta vulgaris*) is a little less certain. It did grow wild in parts of southern and middle Asia. The beet plant played a minor role in the ancient past, as Herodotus wrote that the beet was one of the plants that helped nourish the builders of the pyramids. Augustus Caesar also mentioned the sugar beet as being the principal food for the slaves of Rome.

However, it wasn't until 1590 that Olivier de Serres, a French agronomist considered to be the father of agriculture, wrote, "The beet-root when boiled, yields a juice similar to syrup."[6]

Though the sweet properties of the beet are mentioned, it would be another century and a half before, in 1747, a German chemist, Andrew Marggraf, became the first to obtain sugar from the beet. Yet another half century would pass before one of Marggraf's students, Franz Karl Achard, was able to present a commercial use for the beet. Achard claimed that sugar from the beet could be produced for six cents a pound, a price that threatened the British holdings in the West Indies. After refusing a $100,000 offer from British authorities, Achard became part of one of the earliest sugar wars.

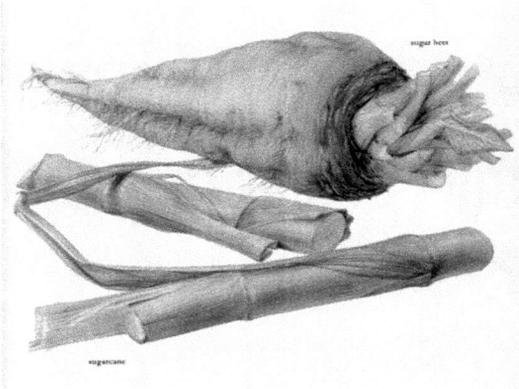

Beet and cane sugar. Once processed, the final product looks relatively the same. The advantage of beet sugar is that it is cheaper to produce, and the beet plant thrives in a wider range of climates. *Author's collection.*

Franz Achard kept his findings at home in Germany. Through the financial support of Frederick William III, the construction of the first sugar beet factory in the world was begun in 1799 and completed by 1801. It was located on Ashard's estate at Cunern, near Steinau in Silesia (Germany). His early testing proved he could extract a sugar content of 6 percent from the "beet root."

The French were also interested in Achard's discovery, and they, too, tried their hand at raising beet sugar. Unfortunately, their efforts failed due to their lack of technical knowledge. The French redirected their experiments using grapes and found that they could replace cane syrup with grape syrup.[7]

A few years later, England set up a blockade of the French ports, denying Napoleon and his French troops all imported goods, including sugar. Napoleon was forced to establish a sugar industry. On March 18, 1811, Napoleon issued a decree in which he called for the establishment of six schools dedicated to the advancement of the sugar industry. Two important factors arose from Napoleon's decree: 1) government support would influence the production of sugar production and 2) the beet sugar industry would begin its long journey in competition against cane sugar. Immediately, nearly eighty thousand acres were dedicated to sugar beets. Hundreds of students from the schools of medicine, pharmacy and chemistry were transferred to these technical beet sugar schools. By the next year, over forty factories were in operation, and the beet sugar industry was established in Europe.

Soon, the beet increased in sugar content from 2 percent to 5 percent.[8] Soon after the Battle of Waterloo (1815), the price of sugar collapsed. France could not compete with the slave labor of West Indies' sugar production.

One year after Napoleon's defeat, only one factory was still operating. France did not abandon its beet sugar efforts, and in the next decades, the number of factories again increased. By 1836, there were 436 factories in operation in France. Germany was up to 122 factories during this same period.[9] The sugar content for beets grown during this time was 5.5 percent.

The first efforts in the beet sugar industry in America didn't start until the 1830s, when James Ronaldson organized the Sugar Society of Philadelphia.[10] A representative of the company, James Peddler, was sent to France in 1836, and after six months of observing the planting, harvesting and extraction of sugar from the beet, Peddler brought back six hundred pounds of seed.[11] He delivered a favorable report upon his return, along with the seeds, but the first beet sugar in the United States was still two years away from production.

The first beet sugar in the United States was planted in Northampton, Massachusetts.[12] David Lee Child also spent time (eighteen months) in Europe learning about the sugar industry. In 1838, his Northampton factory began a two-year run that brought about disappointing results.

In 1853, the Mormons of Utah imported a complete sugar-manufacturing outfit. Unfortunately, the factory, dubbed the "Sugar House," produced only syrup. The syrup was so sharp in flavor that "it would take the end of your tongue off."[13] By 1855, Brigham Young had shut down the $100,000 project.

Between 1838 and 1879, fourteen small beet sugar factories were erected in the United States. All fourteen factories failed and closed down.[14] In the meantime, the sugar cane plantations of the South were flourishing with the use of slave labor and close-kept industry secrets. This is where the Oxnard family began their sugar dynasty. The first Oxnard to engage in the sugar industry was Thomas, born in Marseilles, France, on July 3, 1811.

WHAT'S AN OXNARD?

The Oxnard name has English origins. An early version of the family name is Oxenherd.[15] The early Oxnards herded oxen on the English countryside. The first Oxnard to view the coast of California may have been Captain Oxenham, who sailed the ship *Pelican* back in the 1500s with Sir Francis Drake.[16] However, as later descendant Henry J. Oxnard recently noted, "It has entered our family lore because of repetition, not because of underlying fact."[17]

The first Oxnard to stay in America and the first in a long line of Thomas Oxnards was born in Durham County, England, and came to Boston around the year 1725. Thomas was a merchant and later the provincial grand master of all the Masons of English North America. His son, Thomas Oxnard II, was born in 1740, and he followed his father's line of work as a merchant and shipowner. Thomas Oxnard II remained loyal to the British throne when the country took sides during the Revolutionary War. The colonists confiscated his property during this period while he was living in Falmouth, Maine, where he also worked as a customs collector. When he returned after the war, he was thrown in jail until the Loyalists were given a pardon. His next venture was into the world of religion, where he served first as an Episcopalian preacher before converting to a Unitarian preacher.

Thomas Oxnard III was born in Falmouth (today Portland), Maine, on April 3, 1775, three months before the signing of the Declaration of Independence. He was one of ten children. Though his father was a Loyalist, this Thomas Oxnard was faithful to the United States. After marriage,

he moved to France with his French-born wife but remained loyal to his American roots. While protecting a French port, Oxnard earned military honors fighting for his country against the British in the War of 1812. Commandeering his cousin Henry Preble's ship, *True Blooded Yankee*, Thomas Oxnard III knocked off twenty-seven British ships and captured an island off the coast of Ireland during the war campaign.[18]

After the war, Thomas Oxnard III settled in Marseilles, France. Thomas Oxnard IV was born a year prior to his father's heroics and a day short of America's thirty-fifth birthday, arriving on July 3, 1811. It is this Thomas Oxnard who ventured into the sugar industry. The Oxnards moved back to America, settling in the Boston area, where they continued in the family's shipping business. Due to health concerns, the family sent twenty-one-year-old Thomas Oxnard IV to the milder climate of New Orleans, where his uncle Henry P. Oxnard had a cotton-buying firm. As the young Oxnard traveled down the Mississippi River via steamboat, word reached the ship's captain that a yellow fever epidemic had swept through New Orleans. Some six thousand people died in twenty days.[19] The captain of the ship had the passengers unload upstream from the city. Fortunately for Thomas, the drop-off point was at Brown's Landing. Thomas knew William Brown's children from his French school days. Brown was a wealthy sugar cane grower in the area. Thomas kept in contact with the family over the next few years while working for his uncle in New Orleans. By 1939, Thomas Oxnard IV had married into the sugar business when he took the hand of Louise Adaline Brown.

The Brown family was originally from Dublin, Ireland. They came to Philadelphia in the late 1700s. Nineteen-year-old William Brown moved to New Orleans in 1803 to work as secretary to the U.S. commissioners for the transfer of the former French territory to the United States as part of the Louisiana Purchase. William Claiborne was appointed governor of the territory of Orleans. Claiborne soon recommended his former secretary, William Brown, for the post of customs collector. Brown served as customs collector from the years 1805 to 1809 (Thomas Oxnard II held a similar position for the territory of Maine).

On March 19, 1809, William Brown married Euphemie LaBranche. Her great-grandparents, Johan Zweig and his wife, were originally from Bamberg, Bavaria, Germany. They arrived in 1721 with several other German families and settled on banks of the Mississippi River, a few miles north of New Orleans. It was during the wedding ceremony of Johan Zweig II that the family's name changed. The officiating notary could speak only French. He had a difficult time with the pronunciation of Zweig. *Zweig* translates to

"twig," or "branch," in English. From "branch," the French official came up with LaBranche, and Johan became Jean. Thus, Jean LaBranche married Suzanne Marchand. They had six children, including Michel LaBranche, father of Euphemie LaBranche.

The LaBranche family soon owned a sugar plantation near St. Charles, Louisiana. William also owned a plantation, but he supplemented his income with the customs job, eventually taking $268,000 to Jamaica. Though he was eventually caught and his property confiscated, William Brown returned to growing sugar cane, and by the time Thomas Oxnard IV married his daughter Adaline in 1839, he was once again a wealthy sugar plantation owner.

Thomas Oxnard IV did not immediately join his in-laws in the sugar business. When his uncle Henry P. Oxnard died in 1843, so did the family's cotton-buying firm. Thomas made the switch from cotton to sugar. In time, Thomas owned three sugar plantations and the Louisiana Sugar Refinery of New Orleans.

The first child born to Thomas and Adeline Oxnard was a daughter, Frances Louise Oxnard, on March 11, 1840. A son, Thomas Oxnard V, was born in 1842 but died sixteen months later. Four more girls followed: Mary Alice in 1844, Euphemie Flora in 1846, Louise in 1848 and Marie Diane in 1848. Both Euphemie and Louise died in October 1850. In 1853, the eldest of the surviving Oxnard brothers, Robert, was born in New Orleans. Benjamin Alexander Oxnard was also born in New Orleans in 1855.

By 1859, and with the impending Civil War on the horizon, Thomas Oxnard sold out his sugar interests. Thomas, Adaline and their two sons, Robert and Benjamin, traveled back to Marseilles, France, for a short period, and their third son, Henry Thomas Oxnard, was

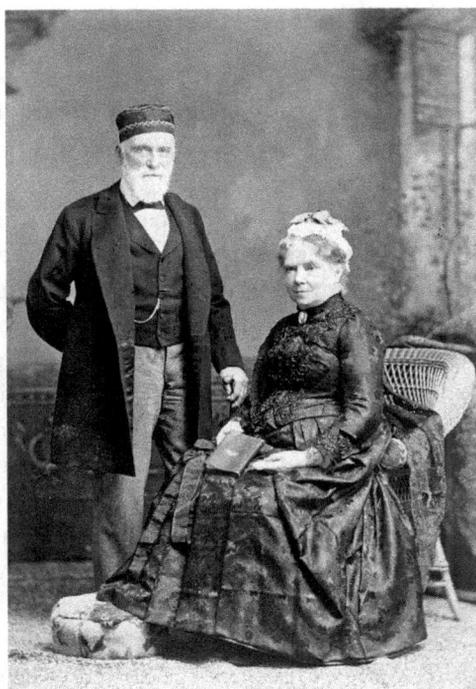

Thomas Oxnard 1V and his wife, Adeline Brown, the parents of the Oxnard brothers. *Oxnard Family Collection.*

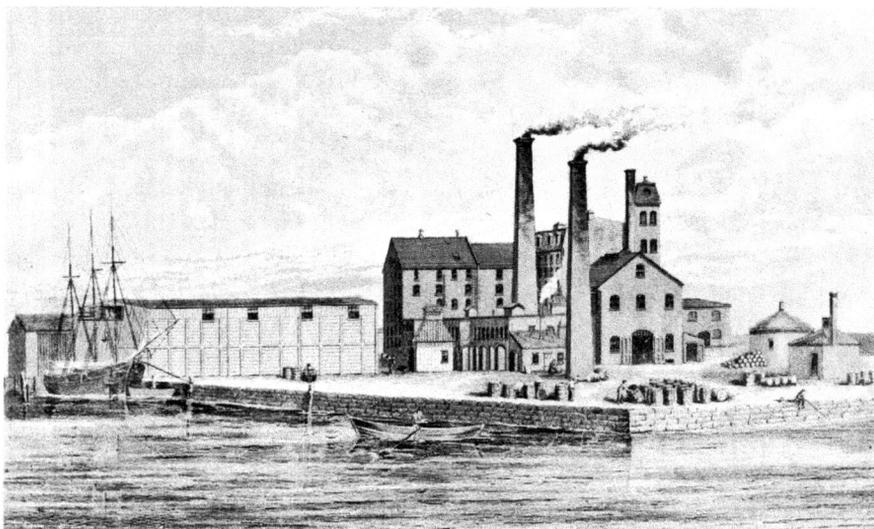

The Oxnard sugar refinery in Boston. *Oxnard Family Collection.*

born on June 22, 1860. The family returned to the Boston area in 1861, and a fourth son, James Guerrero Oxnard, was born in Brookline, Massachusetts.

Staying close to the sugar business, Thomas Oxnard IV engaged in sugar and molasses merchandising. Sometime after 1862, he built the Oxnard Sugar Refinery at 103 Purchase Street in Boston. However, the success of the business fluctuated. Benjamin Oxnard II wrote, "My father told me that when the business was profitable the family lived at Louisburg Square; then in the hard times some of the older children would be sent to live with some of the more prosperous of the Oxnard and Sprague families."[20]

Thomas Oxnard IV brought his son-in-law, Richard Sprague, into the sugar business. Sprague was born in Gibraltar, Spain, in 1830. He married Frances Oxnard in 1860. Sprague supplied additional financial backing for the company. The price of refined sugar was dropping; it went from ten cents per pound in 1838 to three cents in 1876.[21] In 1867, Oxnard sold his interests in the factory to Nash Spaulding & Co. Two years later, in 1869, Thomas Oxnard moved to New York.

During the time of the family's relocation to New York, sixteen-year-old Robert Oxnard moved to Cuba to work for the sugar firm Zaldo & Co. After serving nearly a five-year internship in Cuba, Robert returned to New York in 1875. He was able to help finance the purchase of the Fulton refinery for $85,000.

Right: The Oxnard family's New York home. *Oxnard Family Collection.*

Below: A postcard of a refinery in Cuba. Robert Oxnard spent several years working in the refinery business in Cuba. *Author's collection.*

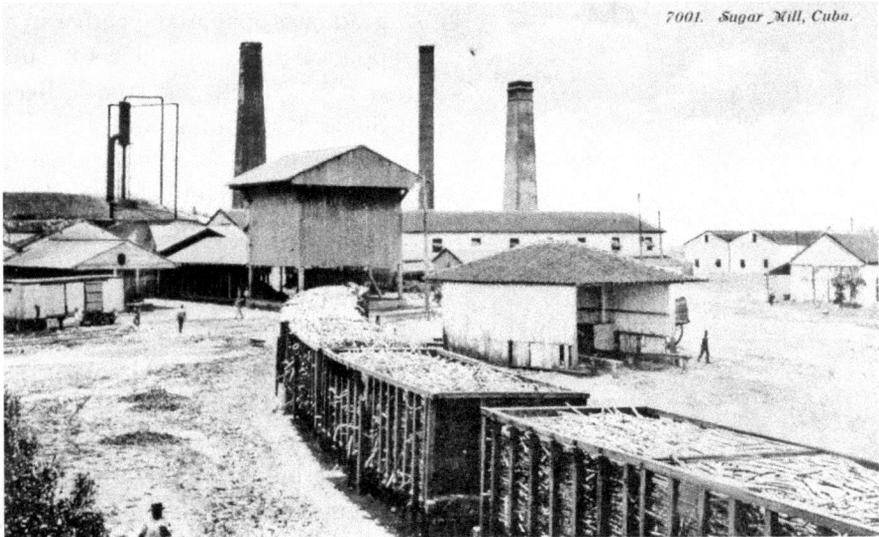

7001. Sugar Mill, Cuba.

Benjamin graduated from Massachusetts Institute of Technology (MIT) in 1875 and served as the technologist in the business. He studied mining engineering because it offered the most chemistry. Ben also joined the family at the Fulton refinery.

The business grew from a capacity of producing three hundred barrels to five hundred barrels. But its investment banker made a request of the Oxnard boys in order to continue doing business: their father would have to step down from the management of the business and be replaced by the eldest boys, Robert and Benjamin. Benjamin Oxnard

II recalls, "My father said that his and Uncle Bob's interview with their father was the most heartbreaking affair the brothers ever experienced."[22]

Henry T. Oxnard was schooled at Harvard, where he graduated in 1882. Another alumni and friend from Harvard, Theodore Roosevelt, would cross paths with Henry many times in the coming years. During Roosevelt's early presidential years, the Harvard graduates appeared together in a political satire in which Oxnard was depicted as the "Beet Sugar King" of a constitutional monarchy. Roosevelt was seen running in disgust, and the U.S. senators were kneeling in front of Oxnard. Yet the two men remained respectful of each other's efforts; Roosevelt even made a special effort to visit Henry T. Oxnard and the sugar factory grounds in May 1903 during his trip through the state. Roosevelt's trip was scheduled for

Top: Henry Thomas Oxnard was instrumental in forming the American Beet Sugar Company and lobbying for favorable legislation to allow the industry to develop. *Oxnard Family Collection.*

Left: James Guerrero Oxnard was the youngest of the Oxnard brothers and was active in the formative years of the sugar factory in Ventura County. *Oxnard Family Collection.*

a 9:00 a.m. visit to Ventura, but he insisted on making a brief stop in Oxnard, backing the train from Montalvo to Oxnard to see his friend's factory.[23]

Out of college, Henry served as sales manager for the family business while his younger brother James worked as the chemist after he graduated from Columbia in 1883.

By 1887, the Fulton refinery closed after being absorbed by the American Sugar Refineries Company, headed by Henry O. Havenmeyer. Havenmeyer formed a sugar trust with the acquisition of seventeen of the twenty-three sugar companies in operation at the time. The brothers were split up. Robert was sent to San Francisco to take control of the California division.[24] His parents and sisters Alice and Marie joined him. Fanny (Frances) and her husband, Richard Sprague, and their family also went to San Francisco. Thomas Oxnard IV died a few years later, in 1891, in San Rafael. Euphemie died a few months after him.

Benjamin Oxnard took over management of the two New Orleans refineries, the Louisiana and Planters Sugar Refining Companies, which were also part of the trust. James followed and worked as the chemist.

Henry was not interested in being part of the trust. Previously, his brother Benjamin had traveled to Europe with Henry Howell to fulfill several objectives—one being to "learn about the manufacturing process of making sugar from beets."[25] Ben had a quantity of raw beets shipped to the Fulton refinery in the early part of 1887, before the refinery was sold. The Oxnards were successful in refining the raw beets. Henry decided to pursue the beet sugar business. He traveled to California to observe the activities of the first successful beet sugar refinery: the Alvarado factory. Henry also traveled to Europe to study beet production methods.

BEETS TO CALIFORNIA

\mathcal{E}benezer Herrick Dyer established the fifty-ton-a-day beet sugar plant in Alvarado, California, in 1870. The Alvarado plant has been credited as the first successful beet sugar refinery in the United States. Yet the truth is, it took several years and four financial failures before Dyer was able to turn a profit at the factory.[26] Dyer hired German technologists Andreas Otto and Ewald Kleinau, who had previously worked at a pilot plant in Wisconsin. After four years, Otto purchased Dyer's Alvarado equipment and transplanted the operation to Soquel, near present-day Watsonville, California. Here, Otto met up with Claus Spreckles. Meanwhile, Dyer tried again in 1879 with the purchase of newer equipment from the Brighton, California factory. The Brighton factory was also started in 1870 but was shut down by the time of Dyer's purchase. One advantage the new machinery had over the old Alvarado equipment was the introduction of a diffusion battery.[27] This is a system where the beets are sliced and transported to a series of iron cells that is fed with hot water to extract sugar from the beet. The Alvarado site was reestablished and continued producing sugar for the next century.

Claus Spreckels constructed the second successful factory. Spreckels was born in the village of Lamstedt, Germany, in 1828. He received little education as a youth and began working for room and board and a slight wage as a teen. During the revolutionary uproar of the 1840s, Spreckels—and thousands of Germans—migrated to America. Within a decade, Spreckles proved to be a successful businessman in the grocery industry, which took him to San Francisco by 1856. By 1863, Spreckels had

Claus Spreckels was also interested in building a refinery in Ventura County at the same time as Henry Oxnard. *Author's collection.*

teamed up with his brother Peter Spreckels and his brother-in-law to start the Bay Sugar Refinery. This plant processed cane sugar, but Spreckels kept his eye open on the beet refining business as well. His obsession with the improvement of the sugar-refining process took him to New York and then back to Germany, where he labored for eight months in the Magdeburg beet sugar refinery. It has been written that Spreckels disguised himself as a common laborer and secured a job in the factory to learn some of the German secrets in sugar refining.[28]

Upon returning to California, Spreckels purchased E.H. Dyer's Soquel beet-processing machinery. After the Soquel factory failed in 1879, Claus Spreckels sent Otto and Kleinau to Hawaii to construct a factory for sugar cane production. Hawaii was prospering from a piece of legislation titled the Reciprocity Treaty, whereby Hawaiian sugar was not taxed in the United States, including Spreckel's San Francisco refinery. As a result, his San Francisco refinery continued to prosper. By 1881, Spreckels had built a new $1 million plant.

With Hawaii on the verge of annexation to the United States in the late nineteenth century, Spreckels again turned his interests toward beet production. He established the second successful beet sugar factory in 1888. He acquired many acres near Watsonville. Spreckles imported experienced factory workers, construction workers and machinery from Germany. The German company Maschinenfabrik Grevenbroich provided the equipment.[29] The factory was dismantled only ten years after completion and relocated to an area south of Watsonville. The city was later named in his honor: Spreckles, California.

During the same period that Claus Spreckels was establishing his sugar factory in central California, Henry Oxnard traveled to Europe to learn

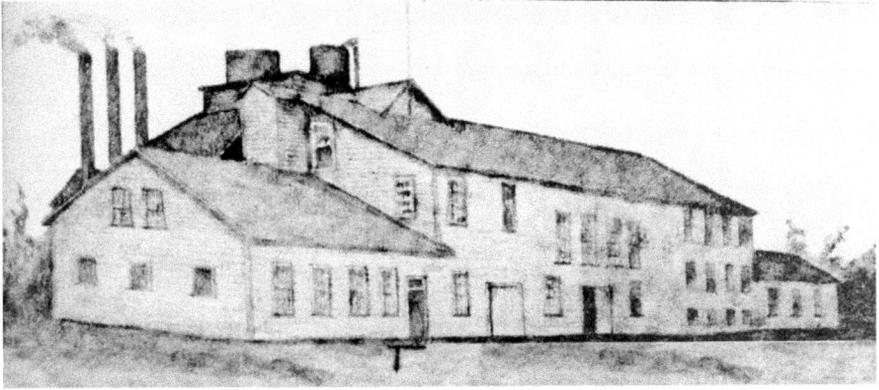

Above: The Dyer sugar refinery that was purchased by Spreckels. *Author's collection.*

Right: The Spreckels Sugar Mill in Hawaii. *Author's collection.*

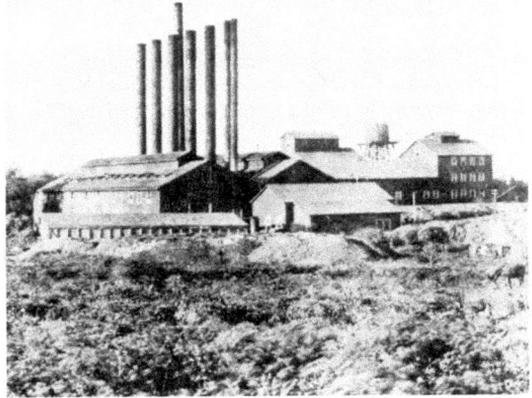

about the refineries in France and to gather some commercial and statistical facts about the sugar beet. The Oxnards were great friends with Charles Kennedy Hamilton and James G. Hamilton, who were bankers and brokers in New York. Charles Hamilton was educated in Europe and was fluent in German and French. Henry was able to convince his friend to travel to Europe with him to learn more about the beet sugar business.

In 1890, the United States recognized the potential of the beet industry with the success of the Alvarado and Watsonville factories. To encourage the growth of the beet industry, Congress waived the import tax on beet sugar machinery.[30] The Department of Agriculture had previously promoted the growing of the sorghum plant for its sugar potential but saw no improvement in the development of the crop. At the request of Lewis S. Ware of

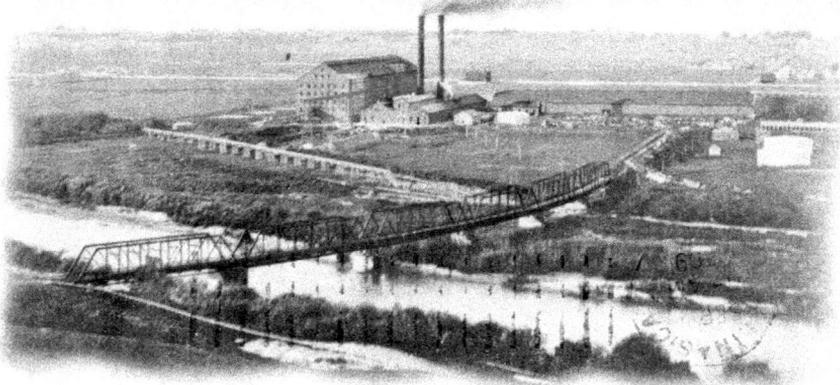

The Spreckels Sugar Factory, (Largest in the World) Spreckels, California

The Spreckles Sugar Company in the Salinas Valley was completed shortly after the Oxnard factory in 1899 and quickly claimed the title of largest sugar factory in the world. *Author's collection.*

Philadelphia and his successful pamphlet campaign, the interests switched from sorghum to beets. Then, through the efforts of Henry T. Oxnard and his brother James, the beet industry received some favorable legislation. The country's first national legislation to encourage the beet industry, the McKinley Tariff Act of 1890, brought a bounty of two cents per pound on all sugar produced in the United States, thus guaranteeing a market for the sugar producers of the country. The tariff became effective on April 1, 1891. In addition to the bounty, the bill allowed for duty-free admittance for beet seed and machinery from Europe.

The Oxnards greatly benefited from this legislation. Henry and James—and, a little later, Robert Oxnard—banded together to develop the beet sugar industry. Benjamin stayed with the sugar trust in the East, which dealt primarily in cane sugar, and was later joined by his brothers in his sugar ventures. Joining the Oxnard brothers in their beet sugar endeavor were investors W. Bayard Cutting, R. Fulton Cutting, James G. Hamilton, C. Kennedy Hamilton and James and C. Kennedy. The largest backer was R. Fulton Cutting, who contributed $4.5 million, followed by James Oxnard, who put in $2 million; the smallest investor was Henry Oxnard, at $1.5 million.[31] They formed the Oxnard Beet Sugar Company (ABS Co.).

The ABS Co.'s first two beet sugar factories were built in Nebraska, in Grand Island (1890) and Norfolk (1891).

Henry and Charles Hamilton traveled to France a second time and contracted with a French company to come to America and build a factory. Henry planned to build a factory near Chino, California, because, at the time, he thought California was the only place he could grow the beets. However, on his return to New York, he stopped off in Nebraska to see a friend and fellow Harvard alumni and learned that the locals were growing a European sugar beet with great success. He was offered free land to build a factory, and Nebraska authorized a one-cent bounty for each pound of sugar, which guaranteed the farmer a minimum return on his investment. Grand Island became home to the Oxnard Beet Sugar Company.[32] A similar story would follow in Ventura County a few years later.

According to Henry T. Oxnard's great-great-nephew, "Most times a site for a factory was chosen according to available water or soil conditions or some other factors. [Uncle] Henry liked the Nebraska area because he remembered it was good 'bird country' for gaming."[33]

The Grand Island factory in Nebraska operated successfully for the next seventy-four years. It would earn the title of the oldest beet sugar factory in America still operating within its original walls. Not until 1965

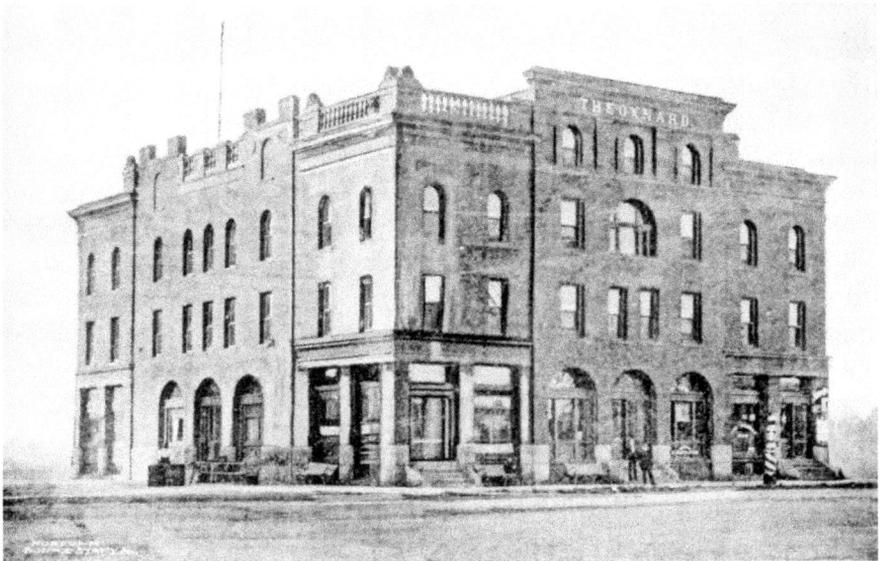

The Oxnard Hotel in Nebraska. *Author's collection.*

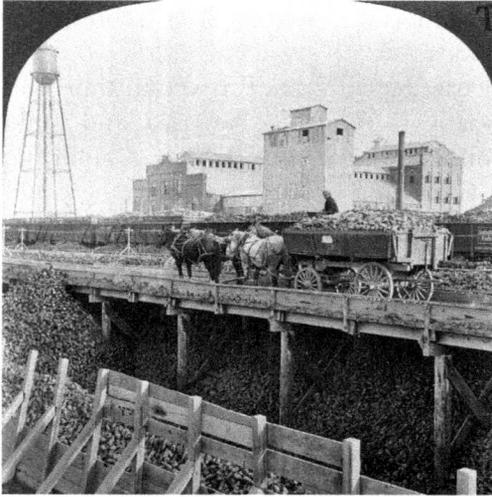

The sugar factory in Nebraska. *Author's collection.*

did those original walls come down. Corn-based sweeteners and obsolete equipment contributed to the decline of the Grand Island factory.

The Norfolk, Nebraska factory was not as successful. In 1905, the Norfolk factory was moved to Lamar, Colorado, and was enlarged to five hundred tons. After five campaigns, in 1912, the factory was dismantled, with the evaporators sent to the Oxnard factory.

The first factory in California was also built in 1891, in Chino. Here, the ABS Co. bought land from Richard Gird. Gird was a native of New York and traveled in 1852 to California, where he ran a large machinery business in San Francisco. In 1862, he traveled to Arizona, and while working for the government as a civil engineer, he surveyed the map for Prescott, Arizona. By 1877, he had become manger of the McCracken mines, and two years later, he founded the city of Tombstone, where he established the Tombstone Mill and Mining Company. By 1882, he had returned to California and purchased the 42,000-acre Rancho Santa Ana del Chino land from descendants of the Lugo family. By 1887, Gird had subdivided the rancho into small ranches and the 640-acre town site of Chino. Gird next began actively courting Henry Oxnard to build a factory on his land over a two-year period. An agreement was made in December 1890. Gird, with plenty of land to offer, gave Henry Oxnard 2,500 acres for the factory site and land for beets, and he guaranteed an additional 2,200 acres pledged by local farmers for beet production and up to 5,000 the following year.[34] With the one-cent bounty from the government for the growers that Oxnard helped legislate, the conditions to build a sugar factory were favorable.

Inspecting the Chino factory on behalf of the United States for the purpose of checking the official weight of the beets was James Alexander Driffill. Driffill worked for the government until the tariff was abrogated on October 28, 1894, by the Wilson-Gorman Tariff, after which Driffill

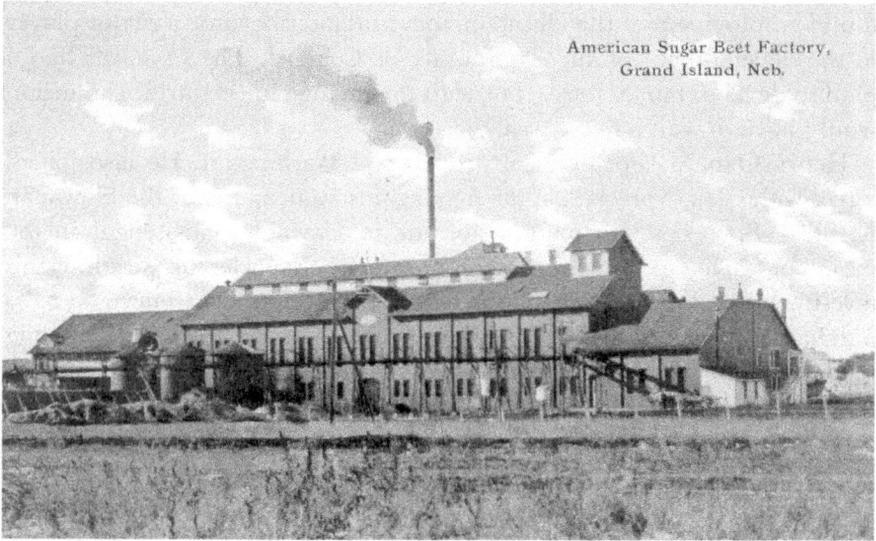

American Sugar Beet Factory,
Grand Island, Neb.

The American Beet Sugar Company built two factories in Nebraska, where farmers received a one-cent bounty on each pound of sugar. The Grand Island factory was the second successfully operated factory in the United States. *Author's collection.*

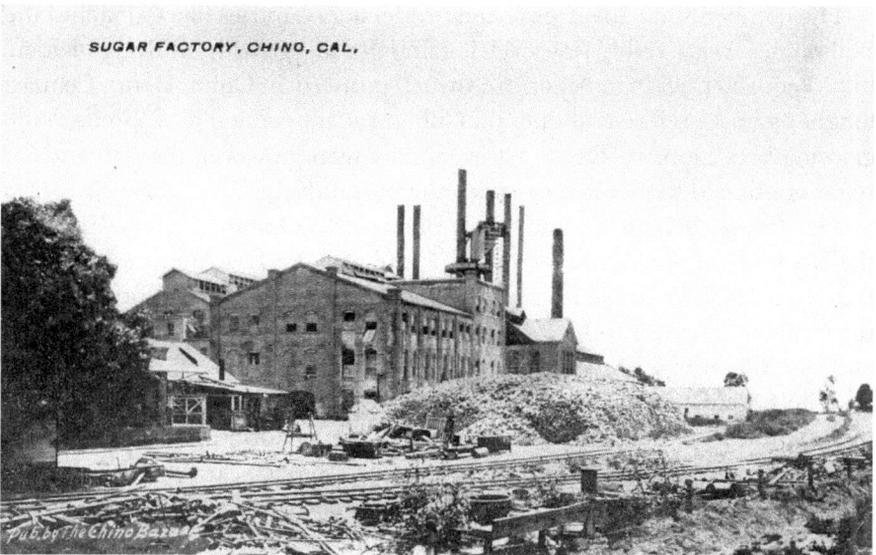

SUGAR FACTORY, CHINO, CAL,

The Chino factory was the American Beet Sugar Company's first California factory. *Author's collection.*

found employment at the Chino factory and later became a major player in the development of the community of Oxnard. The Oxnards had a plan to develop ten factories, but with the change in the tariff, expansion would have to wait a few years.

Henry Oxnard kept political pressure on Washington. He also joined forces with Claus Spreckels in the fight against annexation of the Hawaiian Islands.[35] Spreckles had made a fortune in Hawaiian cane sugar in the past, but a change in government prompted Spreckles to withdraw his investments and concentrate on the beet industry. Speckles went so far as to purchase the *San Francisco Call* in his son's name, for the purpose of fighting the annexation. Oxnard offered his beet growers fifty cents a ton increase if the annexation was defeated.

Though the two men could not stop the annexation of Hawaii, they did get a break from the government in the form of a tariff. When McKinley and the Republicans gained political victories in 1896, the Dingley Tariff proved an easy victory for Congress. This latest tariff taxed imports as high as 57 percent. This helped raise the price of sugar, which was good news to sugar producers. Within two years of the tariff's enactment, twenty-four factories were built, bringing the total to thirty beet factories in operation in the county.[36]

The competition came from cane-producing countries like Cuba and the Philippines. With Teddy Roosevelt leading the charge with his Rough Riders to protect $50 million in American-owned property in Cuba, Henry Oxnard fought against preferential duty on Cuban sugar, seeing it as a threat to the growing beet industry. Roosevelt eventually won; however, the demand for sugar continued to increase to satisfy the beet industry.[37]

The Oxnards built several more plants: the Oxnard factory in 1898; the Rocky Ford, Colorado factory in 1900; and the Las Animas, Colorado factory in 1907. Both the Rocky Ford and the Oxnard factories proved to be successful ventures, but the Las Animas factory operated for only ten years, and by 1920, it had been dismantled.

The Oxnard brothers applied a similar technique as Spreckels in that they supplied the builders and operators of the factories. For the Nebraska factory, the Oxnards imported French machinery, as well as French machinists and builders. The Chino factory relied on German ingenuity for the factory equipment and operators. The Chino factory brought in twenty-five men to operate it.[38] But the Oxnards took their plan one step further than Spreckels; they also included a "training camp" for the local farmers in which the farmers became apprentices in the area of beet sugar production.

The Rocky Ford factory in Colorado was built by the American Beet Sugar Company in 1900. *Author's collection.*

The "Oxnard Brothers' approach succeeded and they earned the credit of establishing the largest training camps for the men who built and expanded the industry."[39]

Meanwhile, Benjamin Oxnard remained in the cane sugar business. After resigning in 1891 as secretary and acting president of the Louisiana and Planters Sugar Refineries for the sugar trust, Benjamin joined his nephew Richard Homer Sprague in opening the Oxnard & Sprague Central Sugar Factory. The name was changed to the Adeline Sugar Factory in memory of Ben's mother and Richard's grandmother, Adeline Brown Oxnard. The sugar plantation was located on the Bayou Teche of the area known as St. Mary's Parish in Louisiana. In 1895, the other three Oxnard brothers invested in the venture, allowing for the purchase of additional land. Eventually, the company was in possession of 7,500 acres, including 2,500 acres of woods and swampland.

During this period, Benjamin Oxnard lived in a beautiful 1840s plantation house. The home, known as the Oaklawn Manor, contained fifteen thousand

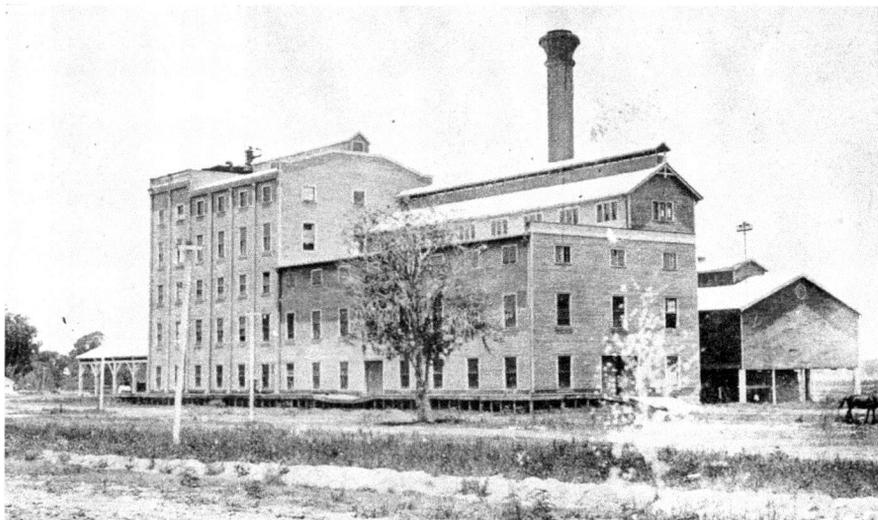

The Adeline Sugar Factory in Louisiana. *Oxnard Family Collection.*

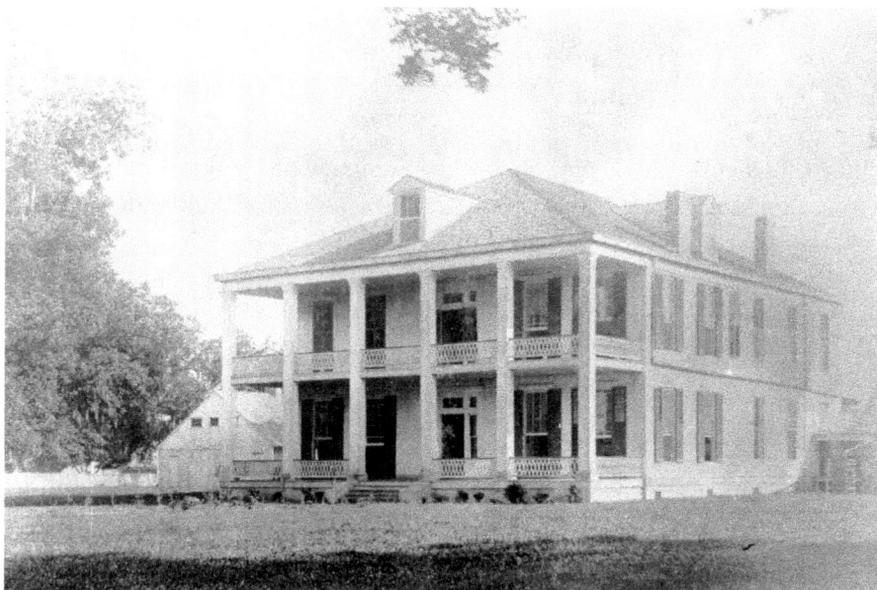

Benjamin Oxnard's mansion in Louisiana, Oaklawn Manor, was built in 1837 and today is a tourist attraction in Franklin, Louisiana, right outside New Orleans. *Oxnard Family Collection.*

BENJAMIN A. OXNARD
1855-1924

W. S. PARDONNER
1868-1931

BENJAMIN O. SPRAGUE
1878-1944

THOMAS OXNARD
1901-1965

Savannah Sugar Refining

1916–1966

Presidents of the Savannah Sugar Refining Company, including Ben Oxnard Jr. *Oxnard Family Collection.*

square feet of living space with twelve-foot-high windows and walls that ranged in width from sixteen to twenty inches.

The factory was capable of producing one thousand tons of cane sugar per day, making raw sugar and molasses. By 1907, the factory was leading the way for the other southern cane factories in producing white, granulated sugar that was ready for direct consumption. When the factory burned down in 1910, a new two-thousand-ton-capacity sugar refinery was built. The white sugar produced at this point was labeled "White Star." Ben Oxnard and Richard Sprague were joined at this time by Richard's brother Ben, who had previously worked for the Oxnards' beet sugar business.

By 1915, after years of floods, freezes and droughts, Ben Oxnard decided he'd had enough of the tribulations associated with growing cane sugar. He turned his efforts toward the refining end of business. To do this, he decided to relocate the plant. Savannah, Georgia, was the final destination. The first years of refining sugar in Georgia were financially draining, but the company held on and began to see a turn toward profit by 1924. However, in August of that year, Benjamin Alexander Oxnard passed away at the age of sixty-eight. W.S. Pardonner took over as president of the Savannah Sugar Refinery for the next five years, before the Oxnard family regained leadership. In 1929, Benjamin Oxnard Sprague served as president until 1944, at which time Thomas Oxnard, Benjamin Oxnard's eldest son, took over as the fourth president of the Savannah Sugar Refinery Corporation. Thomas Oxnard became the fifth generation of Oxnards in the sugar business. His brother Benjamin

Oxnard II also worked for the Savannah company before moving on to the Great Western Sugar Company in Denver, where he rose to the position of senior vice-president.

SUGAR BEETS COME TO VENTURA COUNTY

*A*lbert Maulhardt was one of the first farmers to recognize the need for a new cash crop: sugar beets. In J.M. Guinn's book *Historical and Biographical Record*, published in 1902, the author writes:

> *In order to convince the farmers of the profits and benefits in this new crop and industry, and to show to the manufacturer the adaptability of the local soil for such production, as well as the willingness of farmers to produce sugar beets, he saw a necessity of someone to carry on an extensive experimental beet test under very conservative supervision, and proceeded, at a loss to his own business, to personally secure over two hundred and fifty acres in small lots (Half an acre to five acres) in over two hundred different locations in the valley and had nine tenths of it planted by his own men to insure proper work, going about at times, giving private instruction as to the care of the tests, besides giving lectures on the subject on various meetings and through the press.*

Guinn goes on to say that the results of the tests were "marvelous: in many instances twenty-five to thirty-five of beets per acre were produced with an average of over eighteen percent sugar, and in a number of cases sugar beets containing a maximum of thirty-two percent sugar were obtained."

Verna Bloom notes in her essay "Oxnard: A Social History of the Early Years" that "Albert Maulhardt could talk of nothing else and persuaded many farmers to try sugar beets. He went as far as Carpenteria to talk to farmers."

Above: A sugar beet field. *Author's collection.*

Left: Albert F. Maulhardt, as depicted by the *Ventura Free Press* on October 22, 1897, upon the announcement that the sugar factory was to be built. *Author's collection.*

ALBERT F. MAULHARDT.

However, the topic of sugar beets preceded Albert's experiments by a few years. An article in the *Ventura Free Press*, dated January 1, 1892, proclaimed: "MONEY MADE IN BEETS." This article was reprinted from the *Chino Champion* newspaper and told of a farmer who arrived in Chino without a dollar and planted twenty-one acres after borrowing some money. He ended up

producing 288 tons of beets that averaged 13 and 14 percent sugar. His gross receipts were $1.275.58.

A second article from the same paper on January 8, 1892, reported that the profits from the Claus Spreckles Watsonville factory were from thirty to forty dollars per acre after production costs. Some farmers earned up to seventy dollars per acre.

Back in Ventura County, John Edward Borchard was already growing sugar beers. Thomas Bard's biographer, W.H. Hutchinson, wrote:

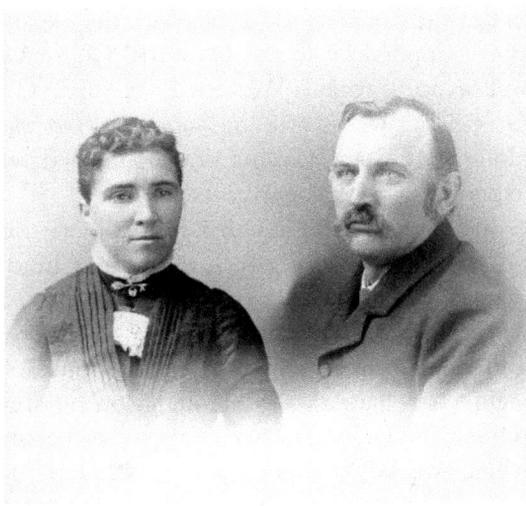

Mary Kaufmann Borchard and her husband, John Edward Borchard. He planted a European variety of beets as feed for his livestock. *Author's collection.*

J.E. Borchard had long raised manglewurzels to tide his livestock through the winters, and a box of his finest and sweetest specimens was sent to the Chino refinery, probably in 1895. This brought him an invitation to visit the refinery at its expense which he accepted accompanied by Albert Maulhardt.[40]

Accompanying Borchard and Maulhardt to the Chino factory was J.E. Borchard's son Henry, who was attending St. Vincent's College in Los Angeles at the time. Albert was a recent graduate from the same school. After a tour of the Chino factory, the men were given some seeds to take back to Ventura County. Also, Albert took with him the lessons learned from Richard Gird's successful bid to bring a sugar factory to Ventura County, which included free land for the site, water and transportation to and from the factory, a pledge for dedicated acreage for beets and education for farmers on the culture of beet production.

Thomas Bard was also interested in the cash crop. Bard is credited as the first person in the state to bring in a free-flowing well near upper Ojai on November 18, 1866.[41] However, Bard was also interested in the potential of the sugar industry.

For Thomas Bard, both Claus Spreckels and the Oxnard brothers were customers of his oil company, Union Oil, which was beginning to make a profit

in the early part of the 1890s with the advancements in drilling machinery. Bard supplied oil to the Oxnards' Chino Valley Beet Sugar Company, as well as to Spreckels Western Beet Sugar Company at Watsonville. Powell Greenland, who wrote the book *Port Hueneme: A History*, suggests that Bard, along with Albert Maulhardt, who farmed next door to Bard, began the first experiments with sugar beets.

In 1896, Albert Maulhardt began a series of plantings, including five acres on Bard's land. Using seed from the Chino refinery, Bard paid Albert to plant, cultivate, thin, harvest and haul the crop to the railroad at Montalvo, where it was shipped to Chino. Four acres were harvested in October and yielded ninety-one tons, paying four dollars a ton. The net profit was eighteen dollars an acre. Hutchinson reports that Bard estimated "a sugar refinery at Hueneme would increase the return per acre to forty dollars, which was better than grain or even lima beans, and sugar beets had the added advantage of being less subject to market fluctuations."[42]

Soon after Albert's experiment with the beets proved successful, he organized a meeting with many of the leading farmers of the area. Richard Haydock, Albert's former teacher, recalls an amusing incident that occurred at one of the early meetings. Not yet twenty-five years old, young Albert, known for his efficiency and minute details, made a request of his friends to make a motion during his speech if his words could not be heard. "This was made to order for those fellows. Almost as soon as Albert began, one fellow elevated his hand; a moment later, another hand went up; and the boys say they almost had him yelling."[43]

To get the Oxnards to commit to the project of building a factory, Albert traveled to San Francisco to meet with Henry Oxnard. He was able to persuade Oxnard to return with him to view the area and witness the commitment of the locals toward establishing a sugar industry. The stage was set. A few months later, Oxnard sent out several of his top men from the Chino factory.

On June 18, 1896, the *Ventura Independent* reported that Louis Hatche, general agricultural manager, along with N.R. Cottman, manager of the Chino Sugar Company, accompanied Albert Maulhardt to various locations throughout the county where Albert had the crop planted. The men examined the soil and climatic conditions. They visited crops in Springville, Calleguas, Somis, Las Posas and Del Norte. It was determined that Calleguas and Colonia were the "best adapted for profitable sugar beet culture." The three major costs for manufacturing the beets would be fuel, water and limestone. Both fuel and water were in abundance, and it was learned that limestone could be procured in Ojai.

Previously, it had been known that most of the land south of the Santa Clara River was too high in alkali and salt content to produce a successful grain crop, but this same soil proved to be a fertile home to the sugar seedling. In addition to producing a high volume of sugar in its stalk, the sugar culture is deadly to noxious weeds and to the farmer's ever-persistent enemy: morning glory.

However, Oxnard was not the only sugar manufacturer interested in the news of the successful initial crops. Claus Sprekels from Watsonville would also make a bid to build a factory if everything was as glowing as was being reported. The *Ventura Independent* later reported, on August 13, 1896, that "steps are now being taken to induce Mr. Spreckels to visit Hueneme and meet out farmers and inspect the 200 acres of beets under cultivation and we hope to publish some encouraging news shortly."

On September 18, 1896, the *Ventura Weekly Democrat* gave Albert the title of "beet-sugar tester":

> *A.F. Maulhardt, our lately appointed beet-sugar tester, expresses himself highly satisfied with the factory at Chino, but thinks beets can be raised more profitably near Hueneme, with its better facilities. Albert states that he was most royally entertained by the managers of the Chino factory lately and feels most grateful for their kindness.*

With Albert's suggestion of building a factory "near" Hueneme, the fate of the area was about to change forever. Though the erection of a factory seemed more and more likely, the builders of the factory, whether it be Spreckels or the Oxnards, was still an uncertainty. The September 18, 1896 issue of the *Ventura Weekly Democrat* reported on two articles from the *Hueneme Herald* concerning the two possible building candidates:

> *A.F. Maulhardt wants the* Herald *to announce to our farmers who raised sugar beets that Mr. L. Hache, of Chino, arrived to make the necessary arrangements to ship the beets to Chino. Weighing and testing will be done at Montalvo. Each farmer will be given due notice as to what part of his beet crop is ripe, and arrangements made for the farmer's convenience in hauling to Montalvo and unloading. All weighing and testing will be done under the supervision of a Chino chemist and A.F. Maulhardt acting for the farmers. Further notice will be given by Messrs. Hache or Maulhardt in regard to the matter.*

The second article was an interview with Claus Spreckels. The article claimed, "Mr. Spreckels has since stated that he will erect a 3,000 ton factory here after January 1, 1896." (The date must have been a misprint; most likely, it was January 1, 1897). The paper boldly stated on that, on October 8, 1896, the beets would "undoubtedly Be Manufactured in the Ventura County."[44]

The same article stated that several farmers met on September 30 at the residence of John Edward Borchard and formed a temporary committee of eight men. Marion Cannon was elected president and Albert Maulhardt secretary. A split between the farmers of Colonia and the backers in Hueneme was beginning to form. The October 8 *Ventura Independent* issue stated:

> *A committee of eight men was appointed to confer with Claus Spreckels in regard to the selection of a site for sugar factory. The farmers of the Colonia are in earnest about the sugar factory, and the people of Hueneme are offering great inducements to have the factory located near their town.*

A deal to build a factory was not consummated after the 1896 campaign, but the government was about to make things easier on the sugar manufactures. The Dingley Tariff of 1897 called for a higher tax on imported goods, including sugar, thus encouraging domestically grown sugar. A rash of sugar factories was on the horizon. One of the first to benefit from the new tariff was Ventura County. The farmers had already done their homework, and they were ready for the big test. A second season of beets was planted throughout the county under the supervision of Albert Maulhardt. At the close of the second year of successful beet production, local farmers were looking to close the door on a deal. The October 8, 1897 *Ventura Free Press* states the attitude of many of the citizens at the time:

> *It is reported that the Oxnards (of sugar fame) are to pay Hueneme and vicinity a visit later this week or beginning next week. We sincerely trust that they have the plans for our (?) factory with them, as the matter seems to be "hanging fire" too long already.*

Getting either the Oxnards or Spreckels to build a factory was beginning to look like it was just a matter of time. By inviting Spreckels, the farmers were protecting themselves and possibly playing a bargaining chip against the Oxnards, who some felt were demanding too much to build the factory. These demands led to a split between Thomas Bard's involvement and the Oxnards'. Among the several conditions the Oxnards

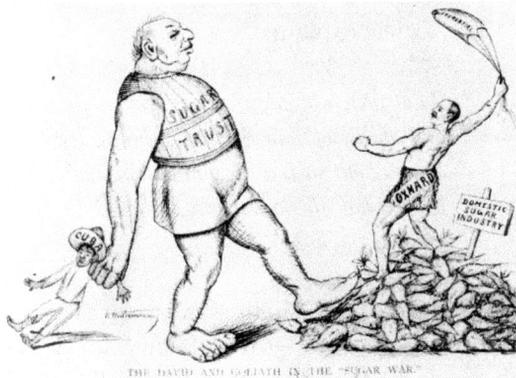

A political cartoon depicting Henry Oxnard representing domestic sugar as David and the sugar trust as Goliath. *Oxnard Family Collection.*

were demanding from landowners was a donation of one hundred acres for a factory site that would be located "one to two miles in an easterly or southeasterly direction from the San Pedro schoolhouse."[45] (The San Pedro schoolhouse was located at the corner of present-day Wooley Road and Rose Avenue.)

In addition to land, the Oxnards further stipulated that a right of way was to be provided from the Southern Pacific Railroad for a spur to the factory site and from that point to the ocean. A final request was for land to be provided at the ocean for the construction of a wharf.[46]

The Oxnards also wanted a guarantee from the farmers that they would dedicate twenty thousand acres to beets for the next five years. On the Oxnards' end, they would build a $2 million facility and guarantee the farmers $3.25 per ton for beets with a sugar content of 12 percent, plus $0.25 per ton for each percentage above that mark.

In retrospect, this seems to have been a bargaining chip on the part of the Oxnards. They were asking for more than they planned to get. The land, climate, water, fuel supplies and, most importantly, superior content of the sugar beets grown in the area were already too good to pass up. By demanding the extra land considerations, the Oxnards essentially cut ties with Thomas Bard, who would not agree to a competing wharf.

On October 22, 1897, the *Ventura Free Press* made the big announcement:

BEET SUGAR FACTORY—Oxnard Brothers Willing to Erect One in Ventura County—A DEFINITE PROPOSITION SUBMITTED—A $2,000,000 Factory Offer Provided, 20,000 Acres Are Pledged to Beets, a Factory Site and Rights of Way to Railroad and Water Front Given.[47]

The article explains:

> *That such a proposition has been made, is due almost entirely to the energy and ability of Mr. A.F. Maulhardt, who has been striving for sometime to bring about such a consummation, and after a conference with Mr. Henry T. Oxnard, in Los Angeles, a few days ago, the following proposition was presented to him.*

A separate article in the same paper reports that the committee of Ventura County men who met with Henry and James Oxnard were T.R. Bard, E.P. Foster, Jacob Maulhardt, A.F. Maulhardt, J.B. Alvord, D.T. Perkins, D.W. Thompson, Leon Lehman, Mark McLoughlin and T.A. Rice. They toured the Chino factory, and Thomas Bard and Albert Maulhardt were placed in charge of the beet contracts. The deal was dependent on enough farmers signing up to grow the beets and get their petitions back to the Oxnards by November 1.

For two years, sugar beets were grown and tested by Albert Maulhardt and his crew. The results of his experiments were very favorable. The highest percent of sugar per beet during the 1897 season was 32 percent, double the amount of sugar found in beets grown in other parts of California.[48] Many Ventura County fields produced 21 to 23 percent sugar, which again far exceeded the sugar content of other areas.

Albert kept meticulous records of his beet production efforts. He broke down the cost per acre of a thorough plowing ($1.75), the cost of planting ($2.25, including price of seed), thinning ($2.50) and topping and hauling (depending on tonnage). The results from Albert's two-year experiment included a profit per acre, after expenses, from $34.00 to $70.00.[49]

Bard and Hueneme were still in the hunt as late as October 28, 1897. The *Ventura Independent* noted that a meeting was held at Bard's Hall, which the Oxnard brothers attended and during which they assured the community that they would build their factory "near Hueneme."

The October 29, 1897 *Ventura Free Press* also reported on the meeting. Among the items discussed at the meeting was the progress of the petition to grow beets. At the time of the meeting, seven thousand of the ten thousand acres were pledged to grow beets. By the next day, the remaining acreage was secured to meet the requirements specified by the Oxnards.

However, by November 26, Bard's name no longer appeared as a participant in the negotiations. Bard's withdrawal from the project has led to much speculation. Dating back to Sol Sheridan's writings, the view was that

Bard was opposed to the "wrong element" the factory would bring. Author Powell Greenland rearticulates that Bard was simply unwilling to give up all that the Oxnards were asking—specifically, the rights to his wharf, as well as his holdings in town, a point hard to argue.

Another consideration that has yet to be discussed is the abominable smell that the towering factory stacks spill out during working hours. It would be a short ten years before the progressive staff at the Oxnard factory would propose the use of kieselguhr as a filter aid, replacing the inefficient bag filter. It's doubtful that Bard wanted the factory too near his extravagant estate in the first place.

A final blow to Bard's involvement may have been when Bard was forced to give Henry Oxnard a right of way to his wharf after Bard learned that Oxnard bought the old starch factory, located about one mile east of the wharf. The starch factory was of little use to the farmers, who had recently given up on growing potatoes. This caused Bard to believe that Oxnard might build his own wharf, and to prevent Oxnard from doing so, he had Henry Oxnard agree not to build a wharf as compensation for the right of way to Bard's wharf.[50]

The most likely reason for the final site location was the fact that it was centrally located, thus benefiting the greatest number of farmers who had to haul their beets to the site or to the beet dumps that eventually sprung up between the factory and the surrounding farmland.

The November 1897 *Ventura Free Press* reported:

> *The site of the proposed beet sugar factory has at last been made public. The factory will be four and one-half miles distance from Hueneme, and on that piece of land known as the old J.Y. Saviers tract. Surveyors have been on the ground every day this week and it is understood that about 60 teams are engaged shortly to haul gravel from the river bed for the concrete foundation.*

As requested by the Oxnards, the farmers donated one hundred acres for the site. The land used to belong to the Saviers family, but Thomas Rice purchased a portion of this ranch in 1888.

> *Maulhardt got the local farmers to underwrite the cost of the 100 acres bought from T.A. Rice, north of Wooley Road and east of Saviers Road. The sugar company paid for the land and for the right of way, collecting later from the farmers by deducting 15 cents from the price of each ton of beets.*[51]

According to an earlier newspaper account, the farmers were actually levied a ten-cent-per-ton tax over a five-year period. A note was drawn up at the October 27, 1897 meeting and signed by "about twenty wealthy land owners." Ventura bankers E.P. Foster and William Collins advanced the necessary money.

The next week, the new beet farmers were out interviewing the potential beet raisers of the area. Among the group were Thomas Bell, Thomas Rice, Jake Maulhardt and John Edward Borchard.[52]

Though Thomas Bard was no longer associated with the Oxnards' sugar factory, he did not give up on the idea of bringing a factory to another part of the county. Along with David Perkins, Bard owned a considerable amount of land in the Las Posas area, near present-day Camarillo and Somis. Only a few weeks after the meeting with the Oxnards at Bard Hall in Hueneme, when it was determined that the Oxnards would build a factory five miles from Hueneme, the *Ventura Free Press* revealed the potential for a second factory in the county:

> *One of the owners of the Alvarado beet sugar factory, in company with the gentleman who built the sugar factory at Los Alamitos, was in the valley this week...These gentlemen are negotiating for a factory to be built somewhere on the Las Posas. Are we going to have two factories? The more the merrier.*

Bard had his Las Posas land tested for beets and soon found out that the plant would not do well. After several strains of beets were planted and tested, he gave up hope for a second factory in the county, but he didn't give up his "sugar" dream all together. Combining his capital with that of E.L. Doheny and other Los Angeles businessmen he'd met after purchasing a second home in that city, Bard formed the Sacramento Valley Beet Sugar Company in 1905. The company purchased a large amount of acreage and built a factory. The Hamilton City factory fulfilled Bard's ambition to manufacture sugar even though the venture did not fill up his bank account. Bard's final investment in the sugar industry came in 1910, when he and several business partners bought a seventy-five-thousand-acre estate in Mexico. The venture fell to Mexico's revolution, and once again Bard's sugar venture remained unfulfilled.

The property deed for the Oxnard factory site was dated November 15, 1897. T.A. Rice sold Henry T. Oxnard one hundred acres of Subdivision 31 of Rancho El Rio de Santa Clara o la Colonia for $25,000, which works out to $250 an acre.[53]

Excavations at the factory site began almost immediately after the property was purchased by the Oxnards. Albert's second challenge in getting the sugar industry established in the county was to secure the funds necessary to build a

bridge. Several people had tried unsuccessfully to convince the county supervisors to build such a bridge; the necessity was not deemed great enough. As early as September 1897, still two months before a final contract with the Oxnards was signed, Albert began petitioning the board of supervisors to build a bridge across the Santa Clara River. Albert brought up the fact that fifty-three thousand tons of grain and produce were hauled across the river at a cost of $10,000 to the taxpayers. The taxpayers in this case were the farmers, who had to pay the additional costs of transporting their goods across the bridgeless river. Albert went on to point out that the current year's produce would be closer to seventy thousand tons. The crop production on the south side of the Santa Clara River was equivalent to the balance of the county.[54]

Two weeks later, on September 24, 1897, the *Ventura Free Press* announced that the board of supervisors was allowing for a $35,000 tax levy for the construction of the bridge. Though the majority of citizens on both sides of the river were in favor of connecting the two areas, many questioned the practicality of building a safe bridge. Sentiment at the time was that it was impossible to drive the pilings for the bridge deep enough into the sandy foundation to secure the footings for the bridge. Albert ridiculed the idea and got Thomas Rice and John Edward Borchard to put up the money for the piles and the work.[55]

While the factory's foundation was being laid in the early part of December 1897, work on the temporary bridge across the river was started. The December 17, 1897 *Ventura Free Press* described the progress: "A temporary bridge has been built and already an engine has gone across, and work is being pushed to completion as rapidly as possible. The track is being laid at the rapid rate of ¾ a mile per day."

Starting from the middle of the river and working toward the banks, two crews of men were able to drive in thirty piles a day. The estimated number of piles to support the bridge was close to nine hundred to cover the four-thousand-foot-wide river. The piles were sixty feet long and driven down at least forty feet into the ground.

From this point, the County of Ventura took over and completed the work. In less than a year, by October 20, 1898, the county was ready to introduce the bridge to the public. The four thousand county residents who attended the dedication ceremony made up the largest gathering of county residents up to that date. Dr. Cephas Bard, president of the Pioneer Society, was the president for the day. According to the *Ventura Independent*:

> *At 10 a.m. a special train loaded to overflowing, left Ventura for the bridge. On the east and west sides thousands stood waiting for the time to move. At 11:20*

a.m. boom went the gun, the east division headed by Grand Marshal T.A. Rice and the Hueneme Band. The west division, headed by Grand Marshal B.W. Dudley and the Ventura City Band, marched to the center of the bridge where a platform had been erected. Misses Merrill Rice and Ethel Dudley, with their guard of honor, viz: Misses Carrie Borchard, Grace Flynn, Arlie Mott, Annie Hartman, Ina Kelsey, and Dora Crane were grouped in front of the speakers stand, Miss Zadie Soule in the center of the group.

The Hueneme Band then played a song selection followed by a short welcome by Dr. D.W. Mott, who introduced Dr. Bard. After Bard's speech and the Ventura Band, Mrs. M.E. Dudley read her poem about the Santa Clara Bridge. Bridge contractor A.W. Burrell then read his speech, which was followed by an oration by W.E. Shepard. The Hueneme Band played another selection, and several people offered their remarks, including Honorable Orestes Orr, Thomas Bard, D.T. Perkins, Robert Ayers, Thomas Bell, W.L. Hardison, N.W. Blanchard, W.L. Hardison, L. Schiappa Pietra, Major Driffill, Henry Bietenholtz (in German), A. Levy, Thomas Clark, Mark McLoughlin and J.E. Borchard. Christening the bridge with water from the river was Zadie Soule. A barbecue and picnic followed.

The final project necessary for the completion of a sugar industry was the construction of a rail line. Previously, in 1886, the railroad had begun building an inland route starting in Saugus, which ran down the Santa Clara Valley to Ventura and then on to Santa Barbara. This was completed in early 1887. Yet there was no link to the other side of the river. With the plans to build a factory, the need for a rail line could no longer be denied.

As early as January 7, 1898, only three months after the Oxnards pledged to build their $2 million factory, the *Ventura Free Press* made a reference to the future town site located half a mile from the factory site.

On January 21, 1898, the same paper announced, "The new town is to be called Oxnard in honor of Henry T. Oxnard." The paper also claimed that an "opposition town" would be started a short distance south of Oxnard.

In 1897, prior to the paper's announcement of the town's name of Oxnard, the incoming superintendent, James A. Driffill, was given the mission of developing the housing plans and supervising the construction of the new factory. "He dubbed the place 'Oxnard' for the convenience of the Post Office, as well as for the railroads."[56] Yet not everyone was ready to accept the Oxnard name for the area. The name of the town was Oxnard, but an official name was still five years away.

A TOWN IS BORN

The Oxnards' next purchase was from Jack Hill. On December 3, 1897, the *Ventura Free Press* revealed that Henry T. Oxnard of New York purchased thirty-one acres from Hill for $6,453. Oxnard also paid Hill and his wife $40,000 for two-thirds interest in their three-hundred-acre ranch. The properties were located to the west of the factory site, and it was here that Major J.A. Driffill would lay out the town site of Oxnard.

The first mention of the new town was reported by the *Ventura Free Press* on January 7, 1898: "The surveyors began yesterday at the new townhouse which will probably be known as Bayard." Two weeks later, the same paper announced, "The new town is to be called Oxnard in honor of Henry T Oxnard." The article also mentioned that there would be an opposition town a short distance south of Oxnard. This never materialized.

In January 1898, the Colonial Improvement Company drew up plans for a city. Major James Alexander Driffill was president of the company and superintendent of the sugar factory. Driffill was born in Rochester, New York. While in New York, Driffill began a long association with the military. He joined the Fifty-Fourth Regiment of the National Guard. After relocating to California, he continued his military involvement and earned the rank of lieutenant for Company D of the Seventh California Regiment. He was next promoted to major. Later, during the Spanish-American War of 1898, Driffill organized a company of volunteers in case there was an attack on the western shores of Ventura County. He even used the sugar factory warehouses as his armory.

Driffill came to California in 1883.[57] He ran a nursery in Pomona, cultivating oranges and other horticultural products. After the nursery suffered through a devastating freeze, Driffill found employment with the government as a revenue officer. He began work at the Oxnards' Chino factory as the revenue officer for the United States government on July 1, 1891. His job was to determine how many pounds of sugar the factory produced in order to earn the two-cent bounty per each pound of sugar. Driffill gained the respect of the Oxnard workers thanks to his loyalty and honesty toward his job. He found employment with the Oxnard family at the factory in 1893, working as a purchasing agent and storekeeper.[58] When the new factory began taking shape in Ventura County, Major Driffill was appointed manager. One of his first duties as supervisor during the building of the factory was to see that the crew worked diligently. To make sure they did not become sidetracked by the temptations of alcohol, Driffill approached the board of supervisors in December 1897 and requested that the board deny any license for the construction of a saloon in the neighborhood of the factory: "The work that had to be done required men of clear head and a steady hand."[59]

In addition to his head position at the factory, Driffill served as the original vice-president of the Colonia Improvement Company. The directors of the company were N.R. Cottman, John G. Hill, Carl Leonardt, Ernest R. Hill and Lewis W. Andrews. C. Portius served as the original secretary.

The town became a boomtown. By February 1898, the town site had been graded, and cement sidewalks were laid out.[60] From this point, the factory site and town site grew simultaneously. As the sidewalks of the town were being formed, the cement foundation for the main building at the factory was completed, as were the derricks needed for hoisting the structural irons. Approximately 182 iron columns were hoisted inside the building structure. The next step was the excavation for the two immense lime kilns. The two kilns would be able to handle 360 tons of lime rock at each charge.

On December 3, 1897, the *Ventura Free Press* described the factory's progress: "Work at the factory site is progressing rapidly and the force of men is increasing daily. Three crews of surveyors have been out for the past two weeks perfecting the lines for the drainage ditch and spur railroad."

Richard Haydock recalled years later that, on New Years Day 1897, there were only three houses within the future town site: J.G. Hill's ranch home, Charles Thatcher's residence (Thatcher farmed on the Hill ranch) and J.Y. Saviers's home at what became the corner of Sixth and the Boulevard.[61]

Within the first six months, starting in the spring of 1898, the bustling town grew to several hundred people with hotels, restaurants, merchandise stores and more. The first home in the new town was built by Ed Abplanalp.

Houses began appearing as soon as a town was projected. Ed Abplanalp built the first one at the corner at Sixth and D streets. He had six men that worked so rapidly they slept in the place the first night it was so nearly finished. Fred Joeneks ran a brickyard in what later became Chinatown.[62]

Abplanalp's house was later moved to Fifth and B Streets and sold to A. Levy.[63]

The first brick building was constructed by S.M. Wineman and was occupied by the Chicago Store, Ben Virden's drugstore and William Fowler's Exchange Saloon.

In addition to new buildings, it seemed that anything that that could be moved from the surrounding communities was taken apart and relocated to the new town. The Ventura firm of Brakey and Son began a long history of moving buildings in Ventura County. Many of the local farmers were also employed to move some of the buildings. Louis Maulhardt supplied his mule teams to the endeavor. Richard Maulhardt offers, "I never realized it until later, but Dad was in the moving business for awhile."[64]

Using mules, ropes, rollers and boards to cover the ruts in the roads, Robert E. Brakey moved houses, saloons, churches and a barn. Using twenty-four horses and six beet wagons, Brakey and his son John started out from Ventura with one of the many buildings he moved to the new town. By the time he got to the Santa Clara River, he had added forty-four more horses, bringing the total to sixty-eight horsepower. John Brakey explained several years later, "It took two hours to get the 14 drivers and swampers all set for the signal to pull and when we finally gave the word the horses took off on a run and almost upset the house in midstream."[65]

Catherine Mervyn reports in her book *A Tower in the Valley*, "Brakey claimed to be such an expert at moving houses with furniture in them; he said he could move a piano with a full glass of water standing on it and not spill it."

From Montalvo, Brakey moved Jack Hills's barn, which became a boardinghouse with Whiteside's florist and Ellis Market on the ground floor. The former barn's new address was 318 South Fifth Street.[66] Also from Montalvo came the Adams Apartments. Three cottages from Hueneme and seven from Saticoy all came across the riverbed and settled down for the next fifty years on A Street between Third and Fourth Streets.

Businesses also relocated to the boomtown. From Hueneme came Wolff and Lehmann, a mercantile store. Wolff soon sold out, and Waterman joined the ranks. Also leaving Hueneme were John Steinmiller's Harness Shop; Harry Witman, hardware dealer and plumber; Jake Diefenbach, tailor; Poggi's Drug Store; B.F. Korts, butcher; the Sim Meyer's Phoenix Saloon; and the Glenn Brothers livery stables.

From Saticoy came the West Saticoy City Hall building. Ben Virden moved his drug business from Saticoy. Dr. G.A. Broughton also left Saticoy for the prospects of a new town. Rufus F. Stewart moved his blacksmith shop from El Rio to the corner of Fifth and B Streets.[67]

Another move to the new town was the original Pleasant Valley Schoolhouse. J.H. Bell purchased it. Bell added a second story, and the building served as a boardinghouse.

Several churches were also moved into town to try to balance out the seven saloons. From Saticoy came the Presbyterian building. The Methodists had a shorter move from El Rio. The Baptists would have to be content with meeting in a railroad car.[68]

Even from as far away as Chino came many new citizens and businesses. Louis Brenneis began his long association with Oxnard after packing up his blacksmith shop in Chino. He became the first fire chief in Oxnard.

The first physician to open up for business was Dr. Broughton, followed by Dr. A.A. Maulhardt, a cousin to Albert Maulhardt. Dr. Maulhardt's first office space was located on the second floor of the Oxnard Hotel at the corner of Fifth and C Streets. Architect J.P. Krempel from Los Angeles designed the hotel. The lower floor included a lounge room in one corner and a spacious lobby. The ladies also had a lobby of their own, with a fireplace and a view that that looked out on a court garden. The dining room was thirty by thirty-five feet, and the kitchen contained twenty by twenty-five feet of space. The second floor contained twenty sleeping apartments with an additional fourteen located on the third floor.

Many other people and businesses would also leave Hueneme, which went from a thriving port town to a quiet seaport in less than a year after the arrival of the sugar beet factory. Even the head schoolmaster, Richard Haydock, would make the move to the new town. Haydock became superintendent of the newly formed Oxnard School District, which replaced the original San Pedro School District. A few years later, Richard Haydock was chosen as Oxnard's first mayor.

The progress of the town was reported in the local papers on a daily basis. Charles Outland referenced the *Ventura Free Press* articles.[69] Some of the highlights include:

An early photo of Plaza Park, circa 1900. *Author's collection.*

March 18, 1898: New butcher shop; beet planning begins; depot building progresses; El Rio blacksmith R.F. Steward moves to the corner or Fifth and B Streets; Lehman and Waterman building started.

March 26, 1898: Post office to be established in Oxnard; Lehman and Waterman open Oxnard store.

April 1, 1898: Factory clubhouse completed; Ralph Hill to be postmaster of Oxnard.

April 8, 1898: Ventura County Board of Supervisors grants three saloon licenses; eight hundred eucalyptus trees to be planted around the sugar factory; first religious service held in Oxnard under the direction of Reverend Furneaux of Saticoy.

April 15, 1898: Sidewalks all finished except "from the square in the center of town."

April 22, 1898: Post office opened but no stamps for sale.

April 29, 1898: "Numerous Accidents": sugar factory construction workers have a bad day, one man killed; American flag flies from the top of the sugar factory chimney.

May 13, 1898: Loose livestock create problems in Oxnard and the beet fields; E.T. Bond to have charge of the railroad station.

June 3, 1898: Opening of Reiman Hotel a "howling success"; Lagomarsino Building nearing completion.

June 10, 1898: First child born in Oxnard to Mr. and Mrs. Wennerholm.

June 24, 1898: Sugar factory nearing completion.

July 1, 1898: Colonia Improvement Company sets out ornamental trees in the plaza.

August 5, 1898: Fires kindled for the first time in factory furnaces.

August 12, 1898: Church services held in German at the "Tabernacle"; grand opening ball at the Reiman Hotel; Henry Oxnard in town.

September 2, 1898: Beets coming in rapidly, with four hundred cars a day being shipped to Chino (probably forty cars).

August 22, 1899: First carload was bought by Lehmann and Waterman.

September 1, 1899: Oxnard Hotel opens its doors.

The two-story Oxnard Hotel was the largest and finest hotel between Los Angeles and San Francisco. The main floor featured a twenty- by thirty-foot dining room, twenty-two- by twenty-two-foot kitchen, a spacious lobby and an office.

One month after the first sack of sugar was delivered to Lehmann and Waterman, on September 23, 1899, sixty-eight people signed a petition in favor of incorporation. A dispute arose over the boundaries that became a four-year stumbling block. In December 1901, another meeting was organized at Engstrum Hall on East Fifth Street. Richard Haydock was elected chair, and a boundary committee was set up that included James Driffill from the factory. The recommendation was to keep the city under one square mile. The consensus was that this was too small an area.

On May 6, 1902, Leon Lehman offered a new proposal. He suggested a two-mile radius. This affected many of the surrounding farms, and the

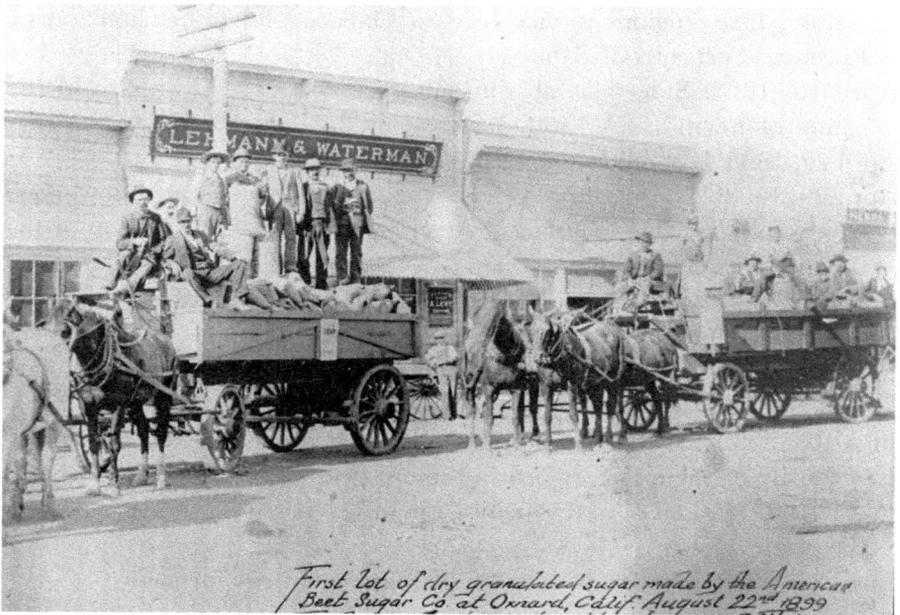

Delivery of the first sacks of sugar from the Oxnard factory to downtown. *Courtesy of Wayne Huff.*

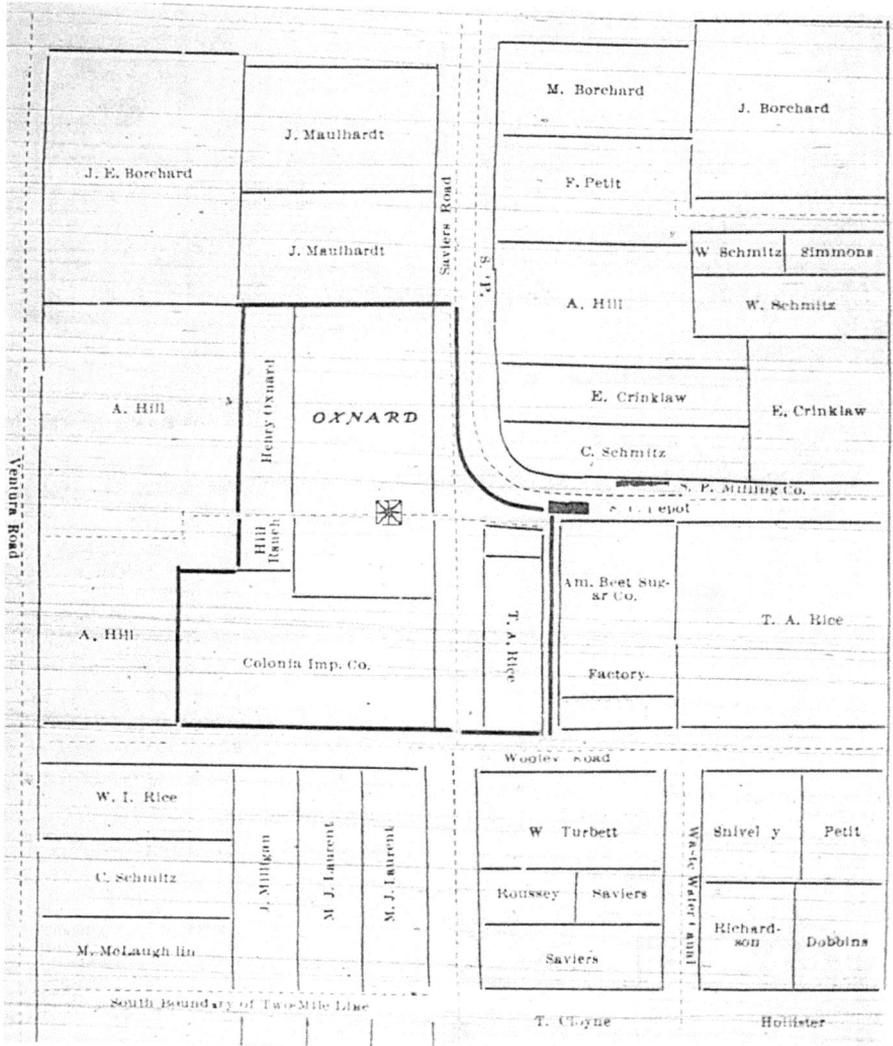

A map of one of the many proposals for city boundaries from 1902. *Author's collection.*

opposing farmers sent their lawyers to argue to their conclusion. The two-thirds-square-mile proposal was presented to the public, and 261 voted against and 11 for incorporation.

After the failed election, a campaign was begun to convince the public of the benefits of incorporation. The final election occurred on June 18, 1903. Held at the Cottage Hotel at the corner of A and Sixth Streets, this

Above: One of the more substantial early buildings was the Masonic lodge, located across the street from the Oxnard Hotel and the Plaza Park. The building later served as one of Oxnard's first movie houses as the Victory Theater. *Author's collection.*

Left: The Bank of A. Levy was located at the corner of B and Fifth Streets before moving over one block to A Street a few decades later. *Author's collection.*

Library Oxnard, Cal. 1907

Above: The Carnegie Building served as the city's first library and city hall and now stands proudly as an art museum. *Author's collection.*

Right: The Oxnard Grammar School was located near Third Street between A and B Streets. *Author's collection.*

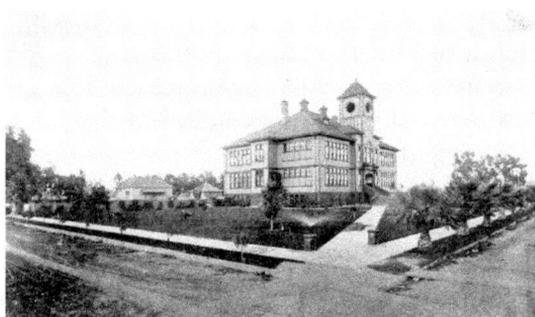

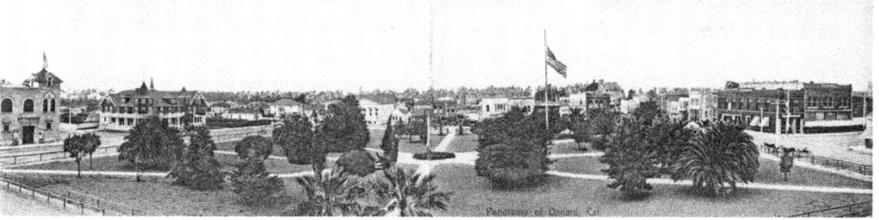

Above: An early panoramic of downtown Oxnard, taken before 1910.

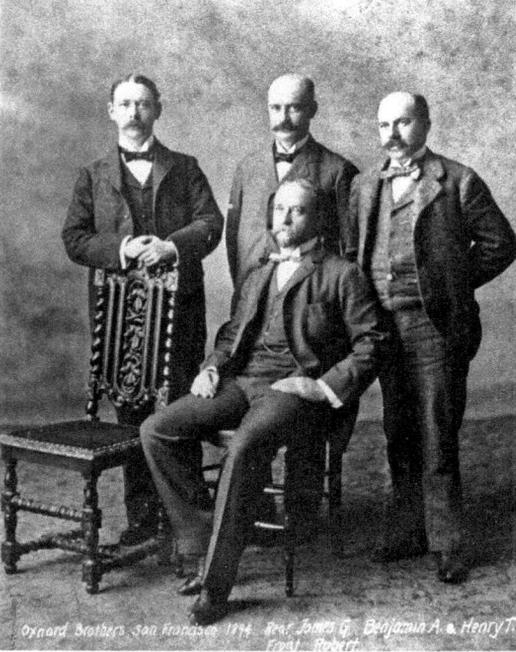

Left: The Oxnard brothers. Standing from left to right are James, Benjamin and Henry. Seated is Robert Oxnard. Circa 1894. *Oxnard Family Collection.*

time, 283 voted in favor and 13 against; 5 votes were voided, and 25 had no preference. Under the Citizens Ticket, five men were elected as trustees, including Richard Haydock, a grammar school principal; Jay Spence from the Bank of A. Levy; O.J. Coen, an agent for the Southern Pacific Railroad; Hill, a real estate and agent and large landowner; and J.W. Parish, one of Oxnard's first building contractors. The city was governed solely by the trustees until 1946, when a city manager was added.

Among the first ordinances passed were a speed limit not to exceed eight miles an hour and the prohibition of gambling within city limits.

Years later, the name of the city came into question. A highly repetitive story recounts the tale. One version was printed in a 1966 article in *PC: The Magazine of Ventura County* on August 21, 1966, and shared by Mrs. James

G. Oxnard, niece of Henry T. Oxnard of Albuquerque, New Mexico. In this iteration, Henry T. Oxnard called Sacramento to offer the name of the city as Sakchar, which is supposed to be the Sanskrit word for sugar, though the spelling doesn't match up. The story goes on to say that the telephone connection had so much static that the request was not getting across, and in frustration, Oxnard snapped and said to just call the city Oxnard. Though the story is fun, the facts are funny. Interestingly, the 1963 article from the *Oxnard Courier* that initiated this tale also contained the disclaimer that the story may have taken historical license to re-create the conversation, and not all Oxnard family members subscribed to the theory.

THE FACTORY YEARS

Henry T. Oxnard formed the Oxnard Construction Company. Its first assignment was the Colonia factory, which became the Pacific Beet Sugar Company in 1897. The Oxnard Construction Company would eventually build five factories: Oxnard was completed in 1898; Ames, Colorado, in 1899; Rocky Ford, Colorado, in 1900; Caro, Michigan, in 1900; and Croswell, Michigan, in 1902. The Oxnard Construction Company also was responsible for the design of the Hamilton City factory in 1906, but the core of the company had been disbanded by that time.

Heading up the team of workers for the Oxnard Construction Company was Carl Leonardt. Leonardt worked his way up the construction crew ladder, starting as a wheelbarrow boss for concrete-mixing jobs. His first work with the Oxnards came in 1894, when he was contracted for the Chino factory expansion. In 1897, he began setting the foundations for the Colonia factory. Using Mike Claasen and his crew, the concrete floors and brick masonry followed. The factory began with a one-thousand-ton capacity, but this was immediately doubled to handle a two-thousand-ton capacity. The Oxnard factory became the second-largest beet sugar factory in the world behind the Spreckles Watsonville factory.

The Pacific Beet Sugar Factory originally consisted of four brick buildings: a warehouse, laboratory, powerhouse and offices, with a fifth building constructed in 1910. The main building was 400 by 130 feet, and though it rose three stories high, five different levels could be detected from

Left: Construction of the sugar factory, circa December 1890. *Courtesy of Jack Wise.*

Below: The American Beet Sugar Factory was in operation for approximately six to seven months out of the year and went through maintenance for the remaining months. *Author's collection.*

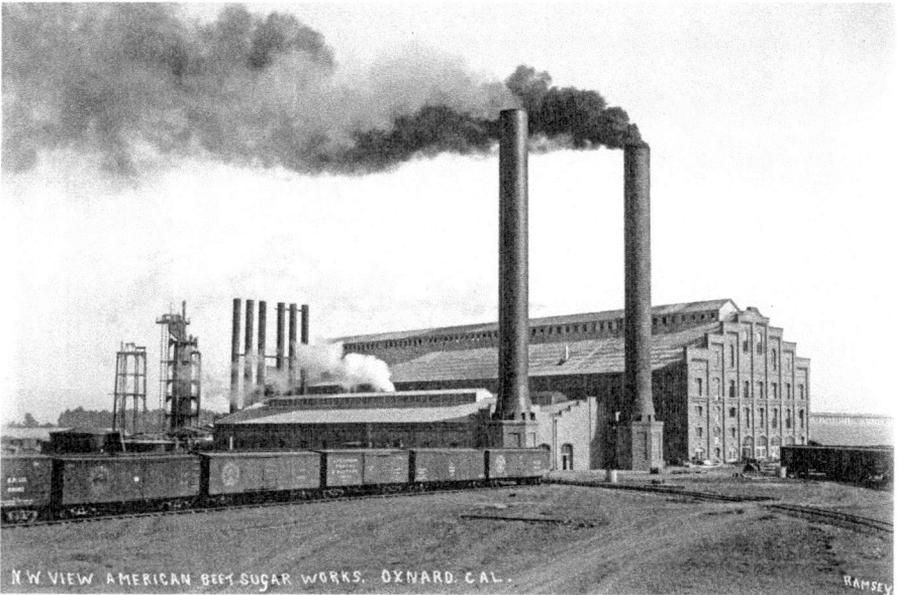

N.W. VIEW AMERICAN BEET SUGAR WORKS, OXNARD, CAL.

RAMSEY

the pictures taken of the main structure. The roof trusses were made of steel and covered with galvanized steel.[70]

The name of the factory went through three changes: the Pacific Beet Company in 1898, the American Beet Sugar Factory in 1899 and the American Crystal Sugar Company in 1834. The two Colorado factories, Rocky Ford and Las Animas, also operated under the name of the American Beet Sugar Factory.

With the factory site completed, the two 150-foot smokestacks became the icons for the Oxnard skyline. Visible from all corners of the forty-

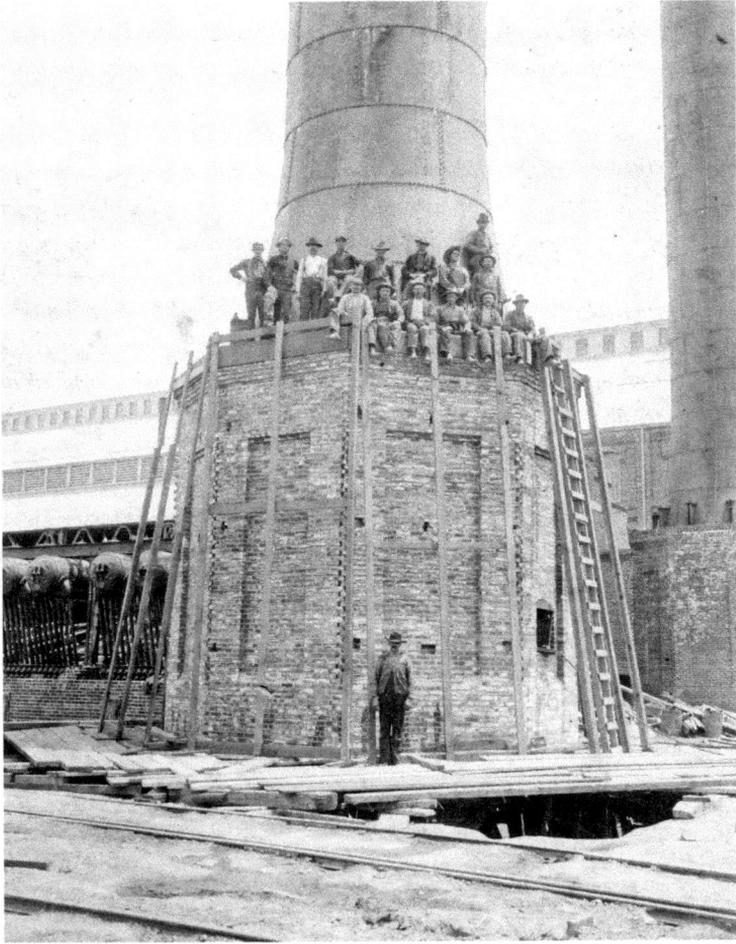

The two 150-foot smokestacks could be seen throughout the entire Oxnard Plain for sixty years. *Author's collection.*

four-thousand-acre Rancho Colonia, the tall smokestacks introduced the surrounding area to the big changes ahead.

A countywide barbecue was organized as a means of introducing the public to the county's largest financial endeavor to date. On January 20, 1898, the *Ventura Independent* made an announcement:

GRAND BARBECUE AT THE FACTORY GROUNDS
A.F. Maulhardt, Secretary of the Committee of Arrangements for holding the initiation of the Sugar Factory, writes the INDEPENDENT *that*

a grand barbecue will be held at the factory grounds in the latter part of January; barbecue in the afternoon free to all and dance at night. The letter closes as follows:

There are several large buildings with surfaced floors, one measuring 250 x 100 feet which will be used as a dancing hall. The evening will be strictly by invitation only. There will be positively no liquor of any kind allowed on the grounds. Music by the brass band during day and evening; dancing all afternoon and evening. Supper at 12 p.m. Everything is to be free...It is our intention to have a train convey all guests from Ventura and such as may meet it at Montalvo, free to the factory grounds...It is the intention of the committee to make this the grandest turnout ever given in this county in honor of the great prize Ventura [County] won in obtaining the Sugar Factory.

A few weeks later, the same paper reported the final details for the celebration, including some interesting activities for the youngsters: "At 2:30 the athletic games will be commenced. There will be long and short distan[ce] running, sack, spoon and other races. The small boys may also climb the greased pole and catch the greased pig. At 3:30 a football game will take place."

This photograph was taken by Ventura photographer J.C. Brewster at the January 1, 1898 gathering at the future site of the factory. *From the Minnesota Historical Society.*

A game of football was also played. Naturally enough, the Lima Beans played against the Sugar Beets. The game ended in an amicable tie, 4–4. A 4–4 score is an unlikely one for a game that counts a touchdown as six points. The game that this imported German workforce played was most likely soccer, to which the Europeans refer as football. These types of games were common among the first few generations of the area. The papers would record other similar activities, but for certain, this event was, at the time, the grandest of the day. Ultimately, over four thousand people attended the barbecue.

The February 10, 1898 edition of the *Ventura Independent* referred to the factory as the "Colonia factory." After inspecting the main building, the large crowd returned for the dancing part of the afternoon:

> *At this time the dancing, with Charlie Donlon as floor manager, began. The Ventura City Band furnished excellent music for the occasion. A feature of the dancing was the prize waltz. Miss Jessie Bates was awarded the first prize, a handsome $5 fan; Mrs. Will Willoughby was awarded the second prize, a case of fine perfumery. Supervisor Crane, C.G. Bartlett and Adolph Camarillo were the judges.*

On February 22, 1898, the public returned for the latest developments at the site. *Minnesota Historical Society.*

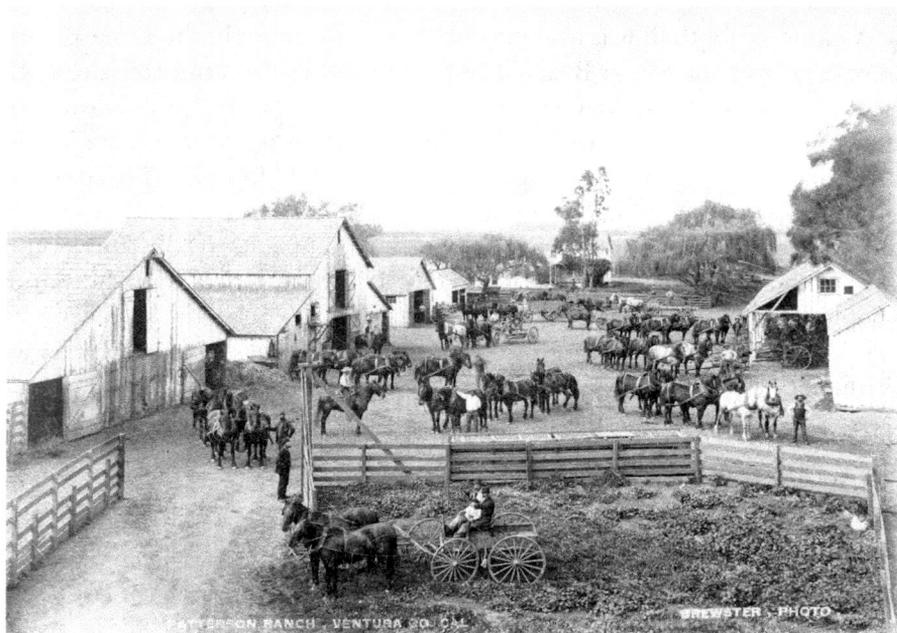

The Patterson Ranch was the largest on the Oxnard Plain and encompassed nearly six thousand areas. *Author's collection.*

The Oxnards also purchased the 5,576-acre Patterson Ranch in July 1899 from J.D. Patterson for $499,000. Located between present-day Ventura Road in Oxnard and the Pacific Ocean, the ranch consisted of two hundred draft horses and nearly three thousand head of cattle.[71] A team of agronomists was employed to ready the soil for growing sugar beets. Over thirty miles of tile drains led the excessive water from the ground to a pump near the ocean. The water was then pumped out to the ocean.[72] Serving as president of the Patterson Ranch Company was Robert Oxnard, while J.H. Rathborne served as the first secretary and treasurer. James A. Driffill became the registered agent for the company, and Charles J. Daily stayed on the first two years as superintendent of the ranch before deciding to farm for himself in Camarillo. Daily was replaced by John Roupp of Chino.[73]

The other large land purchase was the Springville Ranch. This 1,500-acre ranch was located five miles east of Oxnard, near Camarillo. The 6,000 acres to the south of Springville Ranch were purchased separately from Thornhill Broome, who lived in Chicago and worked for the Chicago Stock Yards Company. The negotiations for this purchase were aided by Hubert Eastwood

and would require Eastwood and American Beet Sugar Company (ABS Co.) representative John Rooney travel to Chicago to negotiate.

For all of these lands, the ABS Co. paid $1,089,612.

Robert Oxnard's involvement as president of the Patterson Ranch Company, as well as his term as president and vice-president of the American Beet Sugar Factory from 1905 to 1922, may have led the town officials to consider Robert Oxnard as the prime mover of the Oxnard brothers. In 1949, Robert's nephew Benjamin A. Oxnard received a letter from E.O. Imus. Imus was the city's engineer, and he wrote to Benjamin indicating the city's intention to cast a bronze statue of Robert Oxnard on top of a fountain that was to replace the pagoda at the Plaza Park in the city of Oxnard. Benjamin A. Oxnard wrote back indicating that it was Henry who was the prime mover behind the initiation of the Oxnard factory.[74]

After his involvement with the factory in the early years at the turn of the century, Henry T. Oxnard spent the majority of his time on the East Coast. In March 1903, he bought an old plantation, the Beverly estate in Virginia, consisting of 650 acres.[75] Robert, however, made frequent visits to the area from his San Francisco home. He regularly participated on the American Beet Sugar bowling team at the Oxnard lanes. As vice-president of the company in November 1917, Robert Oxnard made a speech at the annual factory barbecue. In the speech, Oxnard reminded his audience that nineteen years earlier, lima beans were selling for two and half cents a pound. Beets were $4.50 a ton and had doubled in price since that time.

8

WORKERS

The labor force has always been in demand in agriculture. During the dry farming years, harvest time was the most critical to find enough workers. As mentioned in the "Early Agriculture" chapter, many of the first farmers worked for one another. They would supplement the workforce with the older school-age students, who would skip school for weeks at a time during fall season and again at planting time, while the older girls would often miss Mondays to help with laundry and other household chores.

However, with the introduction of the cash crop of sugar beets, larger numbers and more frequent use of workers were needed. Another factor that influenced the labor force at the factory was that the work was seasonal. The campaign started in September during the beet harvest and lasted approximately five to six months. This required both skilled and semi-skilled labor. Skilled positions included the foreman; the boiler, keeping the sugar from boiling; the head mechanic; the electrician; the welder; and machinists, and most of these positions required two to three semi-skilled apprentices. Other semi-skilled positions included operators of the carbonators, evaporators and granulators. The least skilled jobs were the janitors, handlers and knife cleaners.

The factory employed between 350 and 500 people during the campaign. It ran twenty-four hours a day for seven days a week. There were four crews filling three shifts. During the inter-campaign, the factory employed about one-fifth of the workforce for repairs and maintenance.

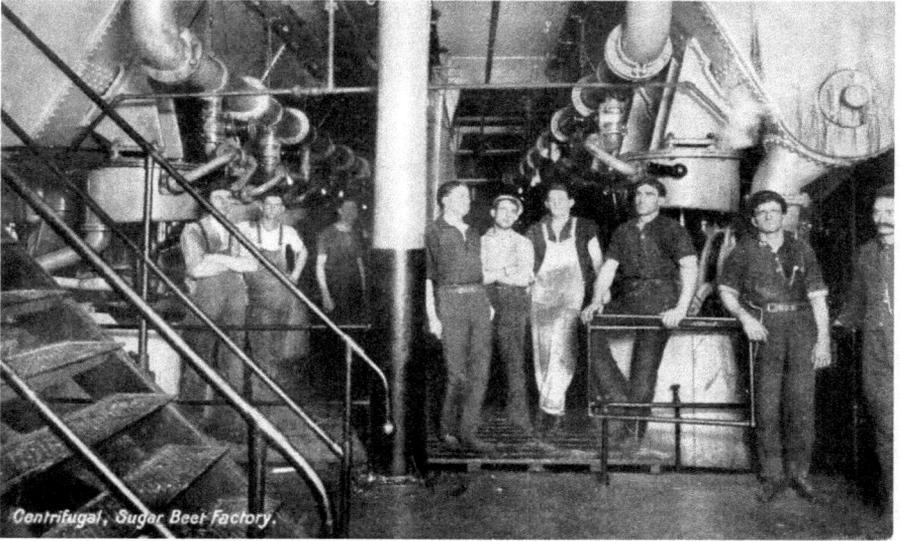

Above: Workers in front of the centrifugal pumps. *Author's collection.*

Left: Workers loading one-hundred-pound sacks of sugar. *Author's collection.*

For workers, the sugar factory depended on labor contractors to fill the fields. The work involved planting the seed, thinning the plants to prevent overcrowding and then topping off the leafy heads of the beets before they were harvested.

The farmer then transported the beets in a beet wagon, one with high sideboards that could be lifted to dump into a railroad car at the raised beet dump. Oxnard had several beet dumps, including the Naumann Beet Dump on Etting Road, the Debo Beet Dump near Hueneme Road, the Arnold Beet Dump off Hueneme Road near Saviers Road, the Round Mountain Beet Dump off Barclay Road, the Sucrosa Beet Dump near Cawelti Road and the Leesdale Beet Dump off Wood Road near Pleasant Valley Road.

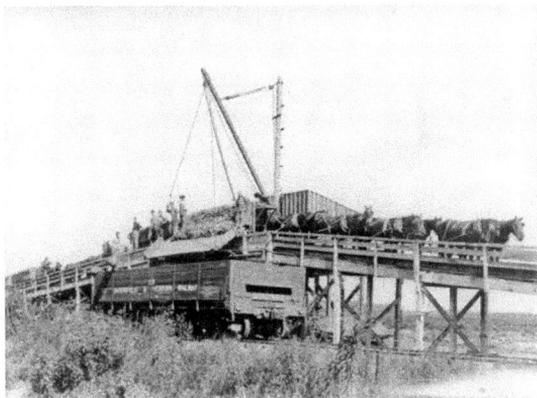

Right: The Naumann Beet Dump.
Courtesy of Frank R. Naumann.

Below: A beet dump on Oxnard Plain. *Author's collection.*

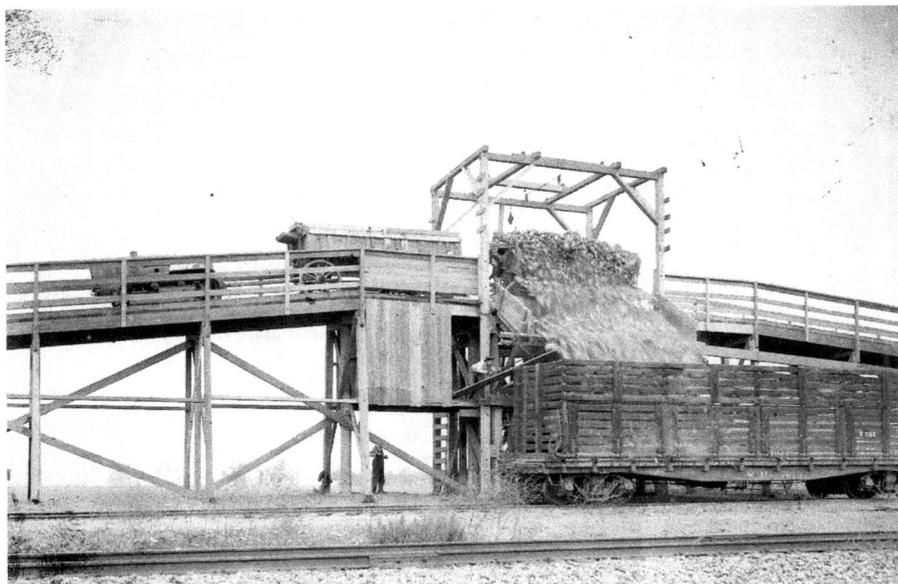

Among the early imported groups of people to work in the beet sugar fields were the Japanese and Mexicans. The Japanese population in California rose from 2,039 in 1890 to 24,326 in 1900.[76] As many as 1,000 Japanese arrived in Ventura County in 1898 to help harvest the area's first extensive beet harvest. With a housing shortage for full-time workers at the factory, the first Japanese took refuge in tents near the beet fields.[77]

Most of the first Japanese to come to Oxnard were recruited from Kumamoto Prefecture in Japan by labor contractor Kusaburo Baba. Baba later organized the Japanese and Mexican workers in

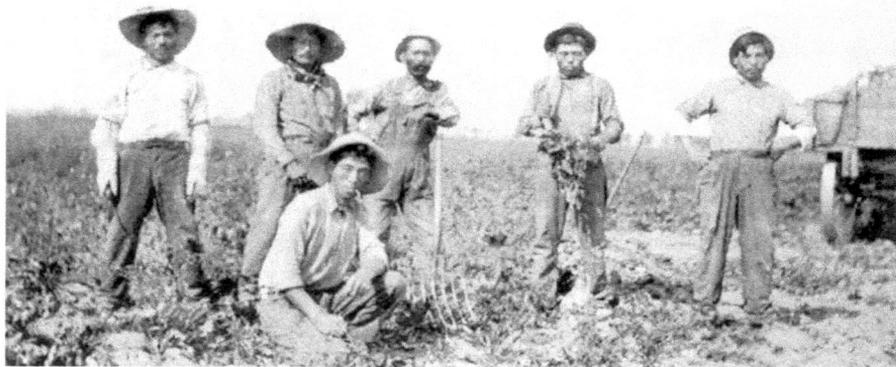

Over one thousand Japanese workers arrived in Ventura County to tend to the beet fields. *Author's collection.*

an effort to improve their working conditions. He was able to unify 1,200 workers in February 1903, and within a month, the Japanese-Mexican Labor Association "defeated" the rival labor contractors, the Western Agricultural Contracting Company, thereby gaining a fair representation for its members. Many other Japanese were recruited from Okayama Prefecture.[78]

Baba's other important achievement for the new citizens of Oxnard was the organization of the Methodist Mission Church. This church became a gathering point for many prominent Japanese families in Oxnard.

Though the Japanese community suffered many prejudices throughout the city's history, many great community leaders emerged from the adversity to establish successful businesses, become accomplished farmers and raise respectful families. Among the early Japanese families who contributed to the community were Asahi, Fugimato, Fugimori, Fujita, Matsumoto, Nakamura, Nishimura, Ogata, Okamato, Otani, Otomo, Takeda, Takasugi and Tokuyama. Others who came soon after included Akitomo, Fujiwara, Hara, Iwamoto, Kodani, Kurihara, Masunaga, Oysuki, Tagami, Tagayuma and Toyhara.

After the devastating earthquake in San Francisco in 1906, Japanese students were required to attend a separate school. Tensions arose between Japan and the U.S. government that led to a "gentlemen's

agreement" in 1907, allowing the Japanese children to attend public schools in exchange for a ban on passports to the United States except for certain cases. This created the "picture bride" marriages that followed.

By 1909, the Japanese accounted for 42 percent of agriculture labor force. They soon began buying their own tracts of land, creating a shortage in the workforce. By 1910, they were growing 60 percent of the sugar beets in California. By 1913, things had changed. The Alien Land Acts were passed, limiting the number of years a noncitizen could rent or buy land to three years. Asians were considered noncitizens by federal law. This was easily circumvented by many successful Japanese farmers by renewing their leases in the names of other family members.

The other early group to work in the beet fields were the Mexicans, though their numbers were much smaller than the Japanese. The first wave of Mexicans who came to Oxnard were from the central and eastern border states. Of the original seven hundred men who banded together to form the Japanese-Mexican Labor Association in 1903, two hundred were from Mexico. Their numbers increased several years later, when the country experienced a civil war starting in 1911. By 1920, half of the labor force in the fields were from Mexico. The Immigration Law of 1924 severely cut back on the number of workers coming from Europe, and again, a steady flow of Mexican workers entered the United States. By 1930, the Mexican population in California was estimated at 250,000.[79]

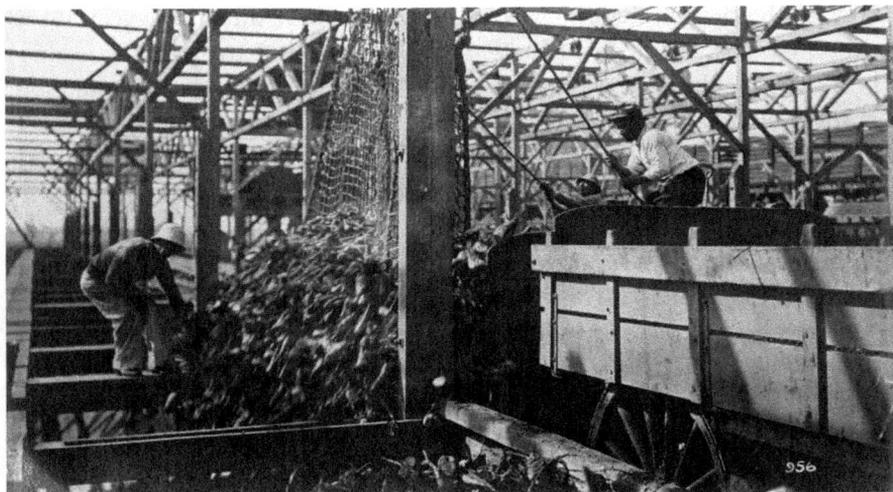

During peak years, the factory employed five hundred workers. *Author's collection.*

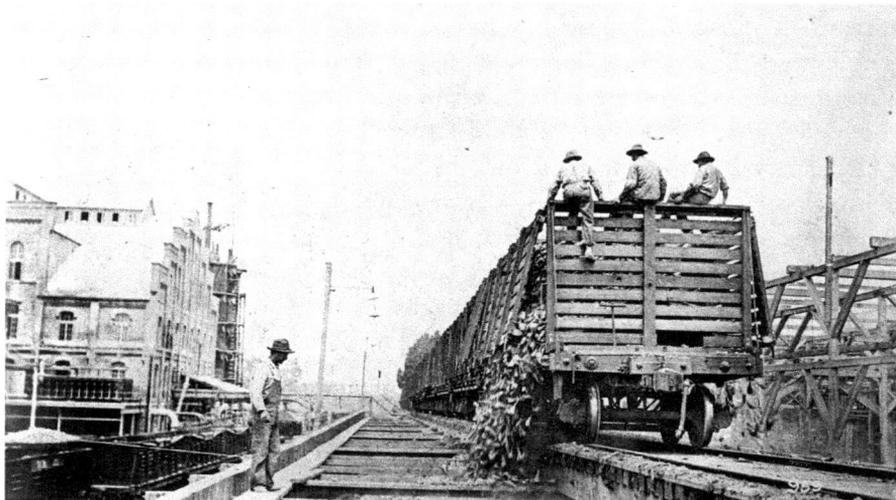

Beets were delivered to the factory as early as August. *Author's collection.*

Among the first workers from Mexico to come to Oxnard was Don Eligio Jimenez, who labored in the factory starting in 1900. The Zaragoza family also came around this time. Mercedes Silveria, who came in 1905, claimed that there were fifty Mexican families in the area when her family arrived in Oxnard.[80]

The original Mexican population was located near Meta and Fifth Streets. Many of the original buildings were made of adobe due to the scarcity of lumber. Wood structures were added to the expanding area, and Enterprise Street became home to many of Oxnard's early Hispanic population. Among the early families to inhabit this area were the Contreras, Ordonez, Ayala and Razo families.

Antonio and Maria Lopez came to Oxnard as early as the 1940s after arriving in California in the 1920s. For a time, Antonio worked at Limco Del Mar and later at the sugar factory in Oxnard. Their son Armando J. Lopez grew up in Oxnard and went on to become a partner in Plaza Development Partners; later, he was involved with the development of the Collection at River Park.

The Colonia Gardens became the next home for the early Mexican population of the town. The land of Colonia Gardens passed though the hands of several farming families before it was subdivided into tracts for homes. The area north of Cooper Road was part of the original Michael Kaufmann property; he purchased the land from Thomas Bard. Kaufman left the property to his daughter Frances, the wife of Justin Petit.

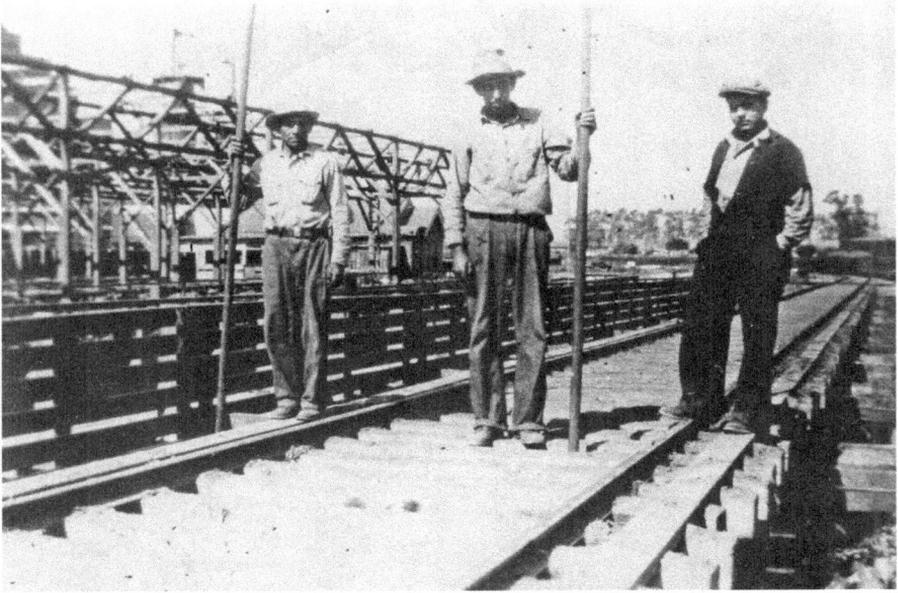

Raymondo Lopez, far right. *Courtesy of Armando Lopez.*

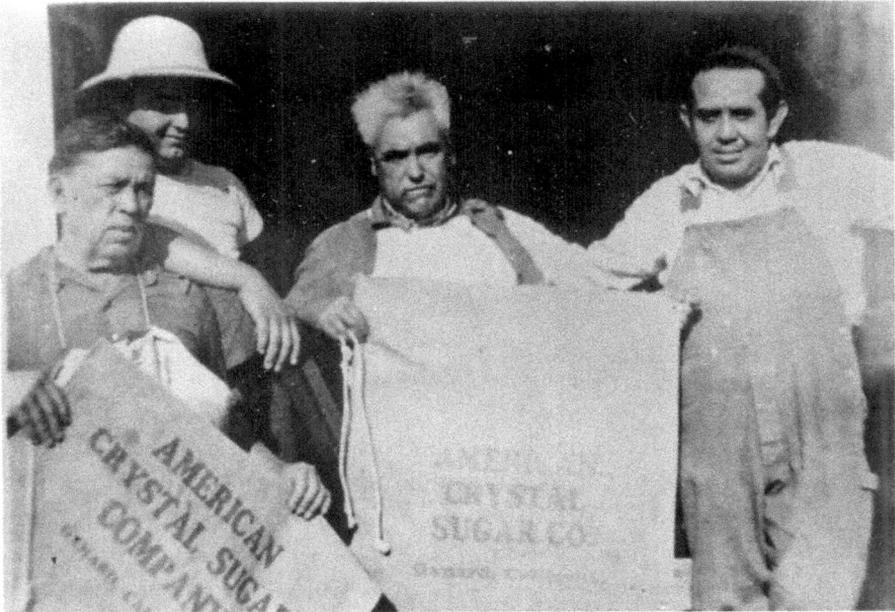

Adalberto Lopez, far right. *Courtesy of Armando Lopez.*

The Cooper family farmed on the corner of Rose Avenue and Camino Del Sol and Del Sol Park. *Courtesy of Carrie Pell Dominguez.*

The land south of Cooper Road passed through the hands of Jack and Arnetta Hill. To the east of today's Juanita Street were the William Schmitz forty-acre ranch and the W.B. Cooper ten-acre farm. Cooper served as one of the area's early sheriff's officers.

By 1921, the area that became known as Colonia Gardens was in the possession of Pete Maria and two partners. Maria sold lots to some of Oxnard's longest-standing Hispanic families. Among the men to build the

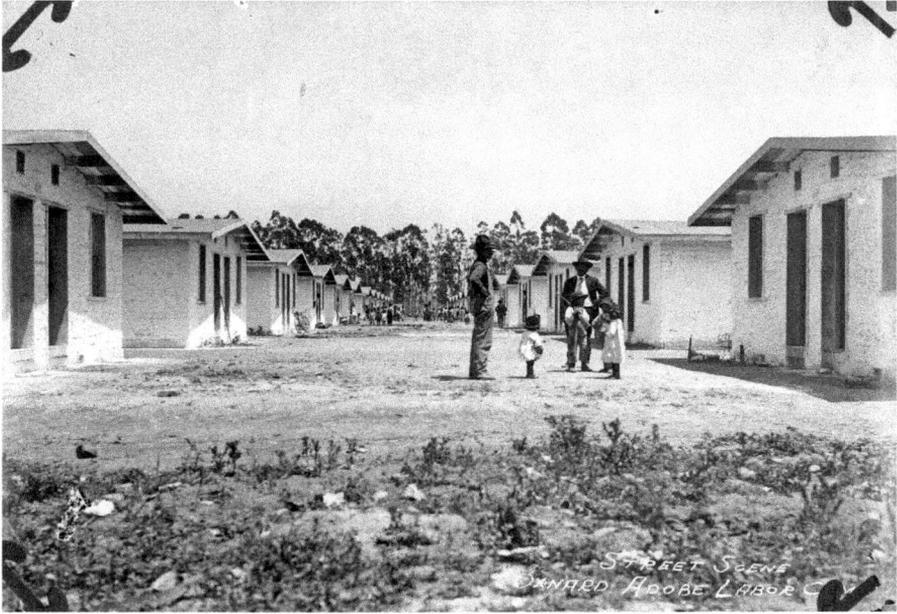

Adobe duplexes near the factory built during World War I. *Minnesota Historical Society.*

first homes in Colonia were Calixtro Segovia, Aurelio Moreno, Cecilio Barra, Jose Martinez and Julian Barajas.[81] Soon, the area boasted its own newspaper, the *La Voz de La Colonia*, run by Jesus Jimenez. By 1923, Jimenez and A.V. Martinez had organized Oxnard's first fiesta, with parade entries from every town in the county. By 1948, after the Second World War necessitated the need for more farm labor, the population of Colonia Gardens had reached eight thousand.[82]

The Bracero Program also brought a steady stream of Mexicans to the area. Each of the world wars caused a shortage of field workers. The U.S. and Mexican governments singed the Mexican Farm Labor Agreement on August 4, 1942, allowing the importation of temporary contract workers from Mexico. The agreement was extended in 1951 with the Migrant Labor Agreement. The program lasted twenty-two years and involved five million braceros in twenty-four states and averaged 200,000 workers per year.

Another of the other early groups to work in the beet fields, but significantly lower in number and for only a brief period, were Hindus. Hindus began arriving to work in California agriculture in the years 1907 to 1910.[83] Their numbers were a lot smaller than many other imported

Sam Camacho Sr. came to Oxnard in 1947 as a bracero and was quickly recruited to become a cook due to his baking background. He was the head cook for the Pacifico Camp. He was also associated with the Buena Vista Labor Camp and Tres Eses Labor Camp, which he later purchased. *Courtesy of Sam Camacho Jr.*

labor groups. Staying together as a group, the majority of the Hindu workers were located in the San Joaquin Valley and the Imperial Valley, though several Hindu groups did put in a few years working in the beet fields of Oxnard.

Later workers included many of those fleeing the Dust Bowl of the Great Plains. As many as 180,000 workers made their way West in the 1930s.

Work at the factory consisted of a variety of jobs. Once the beets arrived at the refinery, they were dumped into bins, or hoppers. The beets were pushed through the hoppers with long poles and washed and rinsed as they moved onto a belt. Once transferred into the factory, they were dropped into a tank of warm water and paddled until cleaned, then weighed. Next, the beets were dropped into big metal bins with sharp knives that cut them into long, thin strips called cossets, and then they went onto another moving belt and were emptied into round kettles, or cells, with lids. The cossets were soaked in hot water to draw out the sweet beet juice. The juice was drawn out and the cossets removed to be dried and used for cattle feed. In another tank, the juice was mixed with sulfur passed though a screen filter and cooked in large metal evaporator tanks. Heated with steam and passed through several evaporators, it thickened after each process and was deposited into white pans in tall metal tanks, mixed with powdered sugar and cooked to form crystals. Removed for the tank, the crystals were covered in brown molasses and put into big metal baskets filled with tiny holes. With the tank closed, the basket was spun until the molasses separated. Hot water was applied, and the basket was removed, with the white crystals put into a big drum

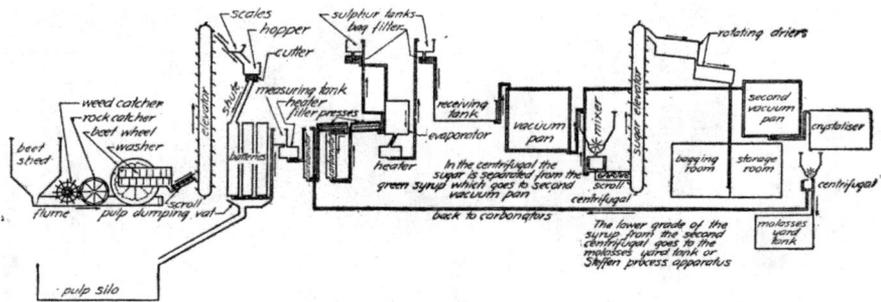

A diagram of the sugar process. *Author's collection.*

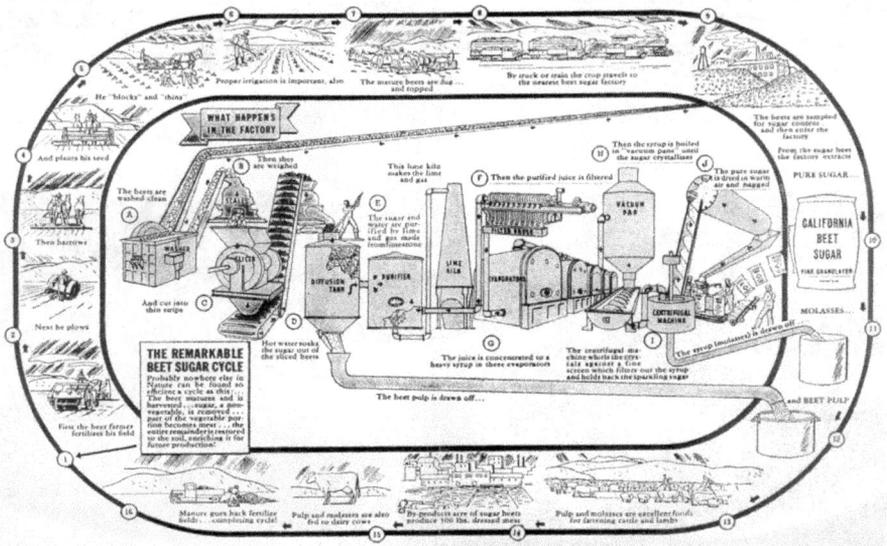

A chart of the sugar cycle. *Author's collection.*

with warm air blowing into the drum to dry them. The crystals were then passed through a screen with different-sized holes for the coarse, fine and very fine sugar product. Moving belts took the different-grade sugars to a hopper that emptied into the different-sized bags.

The sugar factory provided part-time work for many of the teenage population. Chuck Covarrubias was eighteen years old and a senior at Oxnard High School when he took on a shift from 11:00 p.m. to 7:00 a.m. before heading to school in the morning. His duties included working on

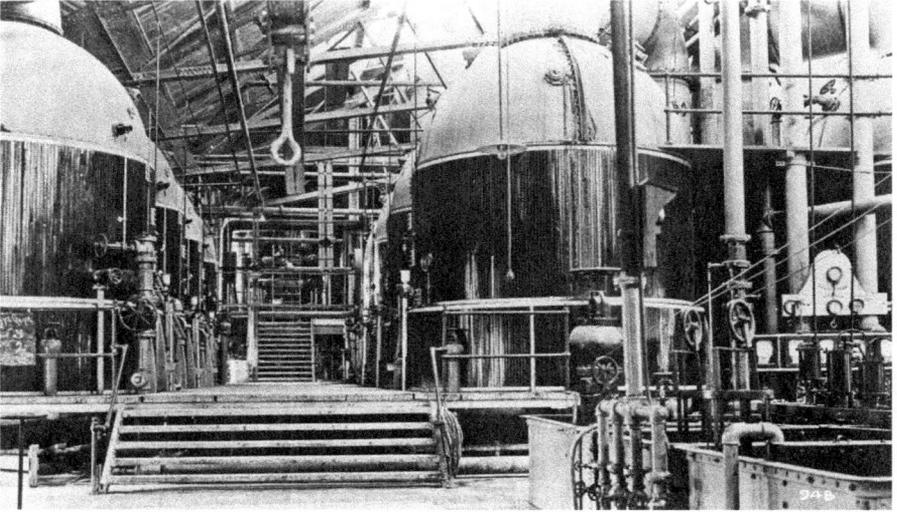

The evaporator tanks where the juice is heated. *Author's collection.*

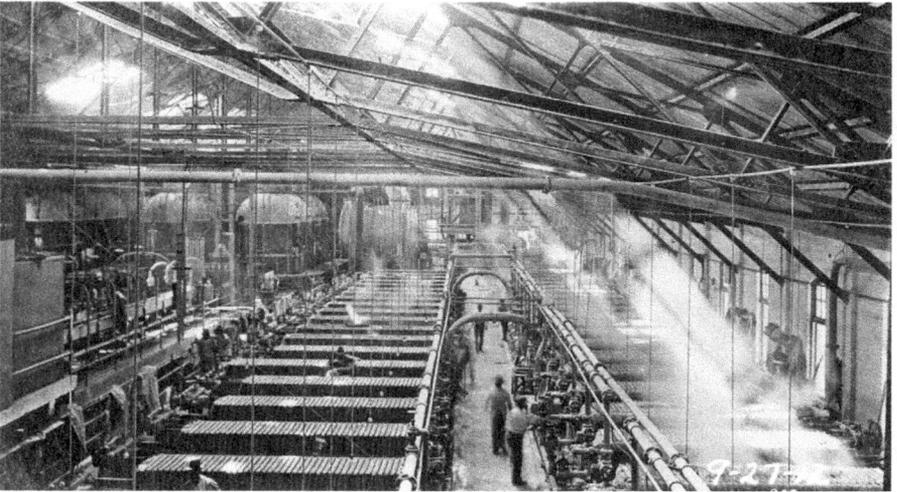

The carbonation tanks, the diffusion battery and the filter presses. *Author's collection.*

a platform and overseeing the molasses, making sure it didn't get clogged in the large vat. He admits to falling asleep more than once, only to be awakened by the sound of a blow from a clanging pipe on the metal surrounding his station.

Loading sugar sacks into a boxcar. *Author's collection.*

Sixteen-year-old Richard "Whitey" Broughton also worked at the factory as a teenager, but he lied about his age, saying he was eighteen in order to get a job. One of his jobs included loading the one-hundred-pound sacks onto a conveyor belt that loaded onto an outgoing boxcar.

LEGACY

By the late 1950s, sugar beets were replaced by citrus, walnuts and row crops. Land prices were rising, and orchards cut back on labor costs while land for row crops could be planted multiple times in a year.

The American Crystal Sugar Company in Oxnard blew the final closing whistle after its fifty-ninth campaign at 3:00 p.m. on October 26, 1958, after a fifty-seven-day fall campaign. (The first year's crop of beets in 1898 was shipped to the Chino factory.) The reason for the shut down was "high cost of modernization, the changing picture of agriculture in our area and the long freight hauls."[84]

By the factory's last year of operation, the local farmers supplied 25 percent of the beets processed at the plant. Only ninety farmers, utilizing four thousand acres, grew beets for the factory's final season.[85] The majority of the beets were shipped by rail to the Oxnard factory, many from the Imperial Valley.

In the sixty-one years of growing sugar beets, and after sixty years of producing sugar in Oxnard, the factory produced 39,525,436 one-hundred-pound bags.

The sugar factory was the city's biggest taxpayer for nearly six decades. With the closing of the factory, the city lost $854,000 of income, or 4.65 percent of the city's budget.[86] Jobs were also eliminated—eighty permanent workers and four hundred field jobs. The immediate plans for the buildings were not known. Rumors of an industrial area began to surface. Then, on April 14, 1959, the *Oxnard Courier* made a big announcement: "ACS Land Sold for $1.5 Million":

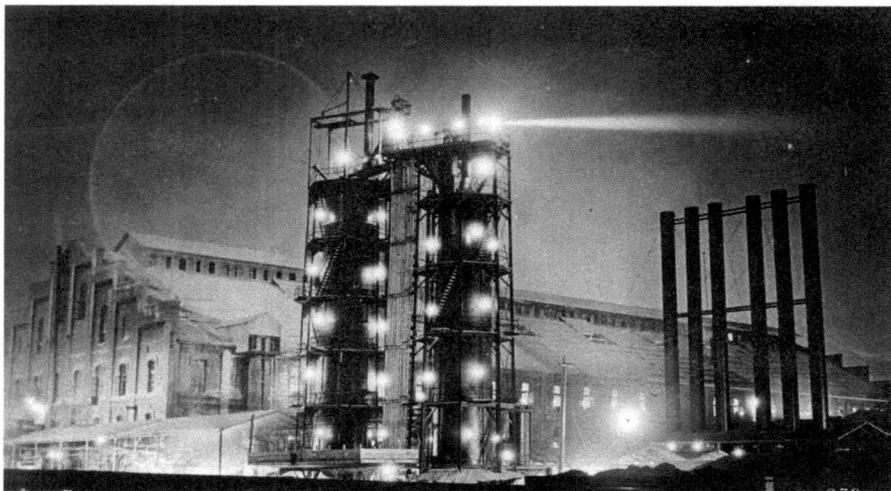

The Oxnard Sugar Factory blew its final whistle in October 26, 1958, after a fifty-seven-day fall campaign. Beet production was down to four thousand acres in its final season. *Author's collection.*

The 124-acre property, as well as the railroad line from Oxnard to Port Hueneme, was sold to four partners: Martin V. Smith, T.C. McMillan, both from Oxnard, Ray G. Barnard from Ventura and H.P. Skoagland of Minneapolis, Minn. However, the company retained three of the factory's main buildings: the main factory, the pulp dryer and the boiler house, as well as the machinery, which was to be disposed of by the ACS Company. The buyer purchased the other two buildings, the offices and the 100,000 square-foot warehouse, plus the nine million gallon a day water well, and two 35,000-barrell-diesel oil storage tanks.

Then came the inevitable news. On July 11, 1959, the *Oxnard Courier* proclaimed: "Landmark Doomed—Wrecking Crews Preparing to Tear Down Sugar Plant."

The wrecking crew Lipsett Steel Products, Inc., took on the task of dismantling the historic sugar factory. Among the wrecking crew's other projects were the dismantling of the French liner *Normandy*, the U.S. aircraft carrier *Enterprise* and many other Southern California plants, but the Oxnard project was its biggest job to date. A crew of sixty men dismantled approximately twelve thousand tons of steel and over eight million bricks. The bricks were sold and reused by the Custom Craft Construction Company.

The last remaining reminder of the factory, one hundred years after its construction, is the former warehouse and office building. Several businesses

Martin V. Smith (behind the podium), along with T.C. McMillian, Ray Barnard and H.P. Skoagland, was among the investors who purchased the 124-acre property for $1.5 million. In this picture of Smith taken in 1965, he is announcing the formation of the Commercial and Farmer's Bank at 155 A Street. *From left to right*: Bob Nesen, Bob Lamb, John Maulhardt, Smith and Dixon Moorehead. *Author's collection.*

have made their homes in the former sugar factory buildings. Most people in the area don't even realize that these buildings still stand. The 1959 headline outlining the wrecking crew's plans may have convinced many citizens that nothing was spared. Years later, in 1966, the grandson of Benjamin Oxnard, Henry J. Oxnard, made a pilgrimage to the area to see for himself the city that carried his last name. After an unsuccessful attempt to contact Martin V. Smith, Henry left with the impression that all of the buildings had been torn down. Many others who have spent far more time in the area have the same impression.

Those who brought Oxnard's lost cash crop died long before the factory did. Of the man whose dream it was to build a sugar factory in Ventura County, Albert F. Maulhardt died of a heart attack at the age of fifty-four. He went on to pursue many other dreams, but none as successful as his first accomplishment. He created a well-drilling company, invested in a couple gold and silver mines in Mexico with his cousins, attempted a citrus industry

Agriculture is still associated with the two remaining buildings and now owned by Western Precooling Systems, which works as a partner for growers and shippers to get the produce from the field to the public. *Author's collection.*

in the Camarillo Heights area and was working on subdividing the same area into ten-acre lots right before his untimely death. Albert's last editorial from the *Oxnard Courier* read:

> *"Community Loses One of Its Biggest Boosters in Death to A. Maulhardt"*
> *To Albert Maulhardt is generally given credit for having more to do in getting the sugar factory for Oxnard than to any other individual. His effective work consisted in getting acreage signed up for the factory, which was a principal condition of the American Beet Sugar Company coming here.*
>
> *He was also instrumental in building the bridge across Santa Clara River. It was said by "Knowing" ones, including the then board of supervisors, that a bridge could never be built because it would be impossible to drive the piles so that they would not be washed out. Maulhardt ridiculed the idea and got the late Thomas Rice and Edward Borchard to put up money for piles and the work in driving them, after which the county completed the job.*
>
> *Maulhardt also gets credit for being the first to use a tractor for plowing. Besides these things he is credited with many other forward*

Other ventures Albert Maulhardt took on included investing in silver and gold mines in Mexico, only to run into the Mexican Revolution, which chased him and his American investors out of the country. *Author's collection.*

movements, including the subdivision of the Pleasant Valley, which was his latest adventure.[87]

Ironically, the Oxnard brothers died within the same time period. The first to pass away was also the first to retire. Youngest brother James Guerrero Oxnard retired in 1910 before he turned fifty. He died nine years later, in 1919, in Pasadena, California, at the age of fifty-eight. James married Caroline Moss Thornton in December 1900 in New York City. Their two

boys, James Jr. and Thomas Thornton Oxnard, were born in New York in 1901 and 1903, respectively. James Jr. took up ranching in Albuquerque, New Mexico. He and his wife had one daughter, Caroline Thornton Oxnard. Caroline and her husband, Thomas Everett Meade, had four children, all of whom were born in Albuquerque.

Henry Thomas Oxnard was the second brother to pass away, on June 8, 1922. Henry married Marie Pichon in November 1900, and they had two children: Adeline, born on November 3, 1901, and Nadine, born on February 19, 1903. Adeline married Baron Richard du Val d'Epremesnil in Paris, France, in 1927. They had three children, all born in Paris. The baron and baroness were both buried in Savannah, Georgia. Henry's other daughter, Nadine, did not marry. She joined her sister in France, where she died in 1970.

Benjamin Alexander Oxnard died in 1924. Ben stayed in the cane business, and although he was not involved in any way with the Oxnard factory, his brothers were partners with him in other sugar ventures. The descendants of Ben Oxnard are the last link in the sugar industry. Benjamin Oxnard Jr. followed in his father's footsteps and worked first for the Savannah Sugar Refinery and then moved over to the Great Western Sugar Refinery in Denver, Colorado. Ben Jr. also picked up the torch as the family historian, and it is through his efforts that many of the Oxnard biographies in the Oxnard papers have been referenced over the years. From these same articles and photographs, which have passed though the hands of the next generation of Ben Oxnards, I was fortunate to borrow and use his anecdotes to give this chapter some depth and credibility. Ben's grandson Benjamin Alexander III is the third generation of Oxnards to work at Savannah Foods, which is the name of the former Savannah Sugar Refinery Company. He is also the sixth generation of his family to be involved with the sugar industry. Thus, the descendants of Ben Oxnard have become the last of the Oxnard name to associate with the sugar business. Ben Oxnard's other son, Thomas, stayed with his father's Savannah Company until his passing in 1965.

Robert, the eldest of the four brothers who dealt in the sugar industry, died in February 1930. While Henry and James were the most involved with the sugar factory in Oxnard during the initial year, it was Robert who paid a biweekly visit from his home in San Francisco. Robert also participated in many social events, including the ABS bowling team, which competed at the Redwood Alleys on A Street. In addition to his involvement in the American Beet Sugar Factories, Robert was also on the board of directors for the Savannah Sugar Refining Company with his brothers. Robert and his wife, Nellie Stetson, did not have any children.

Right, left to right:
Benjamin Oxnard
Sr., Thomas Oxnard,
Robbie Griffin Oxnard
and Benjamin Oxnard
Jr. *Oxnard Family Collection.*

Below, left to right:
Robert Oxnard, Adolfo
Camarillo, Charles
Donlon and Fred
Nobel. *Author's collection.*

Frances Louise Oxnard and Richard Tucker Sprague were married in 1860 in France, during her parents' brief stay at the beginning of the Civil War. Sprague was born in Gibraltar, Spain. They had seven children. Richard and "Fannie" moved to San Francisco after the Brooklyn Refinery was sold. They both died in San Francisco. Richard died in 1898, and Fannie passed away in 1907. Their son Benjamin Oxnard Sprague was the third president of the Savannah Sugar Refinery Company, and his son Robert Oxnard Sprague also worked for the Savannah Company as chairman of the board.

Other Oxnards who have visited the city that was named after their family included Ben Oxnard Jr. In 1983, as part of the eightieth anniversary of the city's incorporation, Mayor Nao Tagasuki welcomed Ben Oxnard Jr., his son Henry James Oxnard and his grandson Donald Oxnard.

Henry James Oxnard, the president the Oxnard Business Park in Texas, and his son Thornton Oxnard, who works for Toyota as the national manager of corporate logistics in Yorba Linda, California, came to the area in 2000. This was Henry's third visit and Thornton's first. They brought with them some valuable photographs and family genealogy that was paramount in the writing of this volume. Thornton returned with his children for a second visit a few months later.

In November 2015, Bob Oxnard, a real estate broker from Florida, checked into the Hilton Garden Inn in Oxnard and contacted me through the visitors' center. He spent two days visiting the factory site, as well as the Maulhardt home ranch, the Oxnard Historic Farm Park, the Henry T. Oxnard District, the Pagoda and the Carnegie Art Museum, Heritage Square, the harbor and

Visiting Oxnard in 2000 and standing in front of the sugar factory plaque on Fifth Street are Thornton Oxnard (left) and his father, Henry James Oxnard. *Oxnard Family Collection.*

the collection. He also had breakfast at BG's Café with the mayor of Oxnard. Bob Oxnard's ancestor Edward Oxnard was a brother to Thomas Oxnard, father of the Oxnard brothers associated with the factory.

James A. Driffill was influential in the foundational years of the city. He laid out the town site of Oxnard and was the superintendent of the sugar factory. He also organized the Colonia

Bob Oxnard dines with the mayor of Oxnard at BG's Café. *Left to right:* Jim Gill, Bob Oxnard, Mayor Tim Flynn, Chuck Covarrubias and Jeff Maulhardt. *Author's collection.*

Improvement Company that built the Oxnard Hotel and helped establish the Bank of Oxnard, as well as the Oxnard Light and Water Company. Driffill was also instrumental in raising money to establish the St. John's Hospital. He passed away in 1917, twenty years after first arriving. One of the first streets in Oxnard was named in his honor, as was one of the first elementary schools.

Joseph Sailer was also an early implant to the area with the start of the factory. Sailer was the original master mechanic and graduated to superintendent after Driffill stepped down in 1915. Sailer also became the mayor of Oxnard from 1910 to 1920. Upon his retirement, he moved to his citrus ranch in Simi Valley but returned every Sunday for church services at Santa Clara and a family dinner with his children and grandchildren.

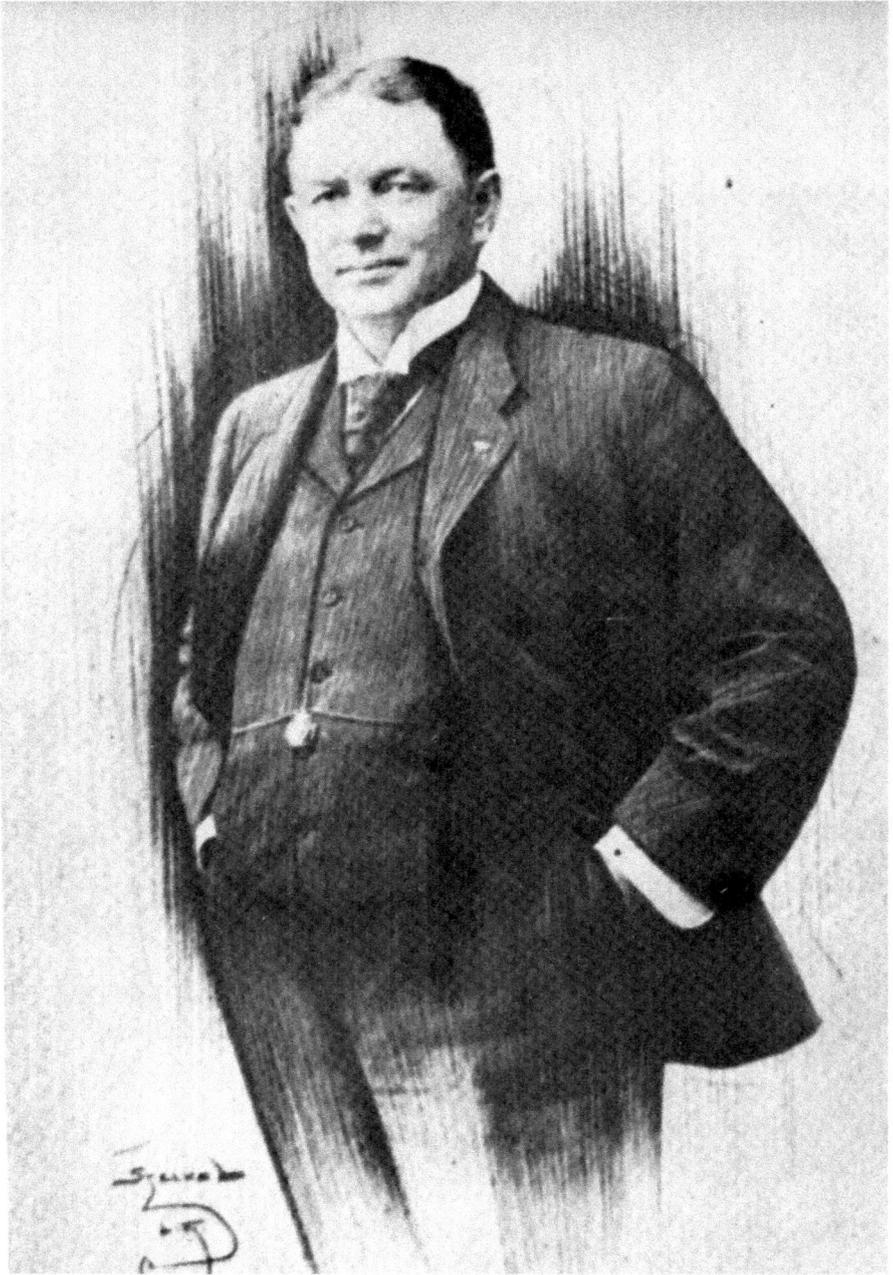

James A. Driffill was superintendent of the Oxnard Sugar Factory and president of the Colonia Improvement Company, which laid out the town site of Oxnard. *Author's collection.*

He also purchased a ranch in Simi Valley, where he spent most of his retirement years.

Agriculture in Ventura County has found several replacement crops over the years. Lima beans continued their tenure as a chief crop through the 1960s, and there were still over ten thousand acres farmed as late as 1985. The oldest lima bean farmer through 2003 was Tad DeBoni, who manned a bean thresher for seventy-two years. At ninety-one, DeBoni worked for Paul Debusschere, one of three remaining farmers growing lima beans through 2016, along with Jim Gill and the Naumann brothers, Mike and Brian.

Joe Sailer (right), former master mechanic and mayor of Oxnard, retired to his citrus ranch in Simi Valley. *Author's collection.*

Other cash crops followed the sugar beets. Citrus was first planted commercially in Santa Paula in 1893, when Nathan W. Blanchard and Wallace L. Hardison purchased 413 acres from Jacob Gries in 1893. They grew lemons, Valencia oranges and walnuts. They named their venture Limoneira after the Portuguese name for lemon lands. With the addition, in 1901, of C.C. Teague, who became chairman of Sunkist and founded Diamond Walnut, the company expanded. By 1924, Limoneira had become the largest lemon grower in California. By the 1930s, lemons had taken on the top position of agricultural products, and by 1947, lemons were poised to hold that spot for the next fifty years. More than one hundred years after Limoneira was established, it produces nearly 11,000 acres of lemons, avocados, oranges, specialty citrus, pistachios, pluots and cherries.

Avocados are another cash crop that has seen success in Ventura County. The avocado originated from south-central Mexico. Judge R.B. Ord of

Young Mason Covarrubias surveys the work of Tad and David Deboni as they thresh lima beans, circa 1990s. *Courtesy of Chuck Covarrubias.*

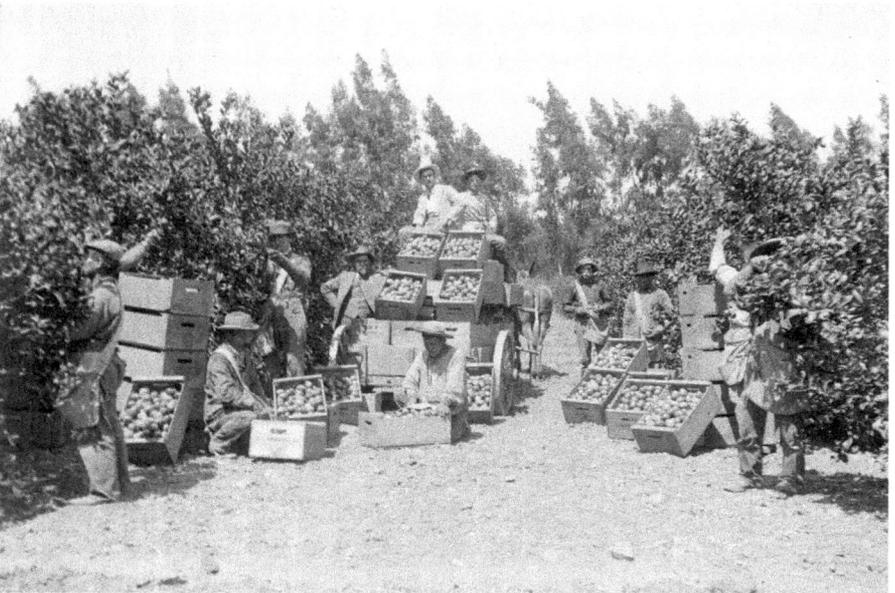

Picking citrus for Limoneira, circa 1900. *Courtesy of Limoneira.*

Over 120 years after planting its first orchard, Limoneira has expanded to include eleven thousand acres in the agricultural production of lemons, avocados, oranges and more. *Courtesy of Limoneira.*

Santa Barbara introduced the avocado to California in 1871, when three tree saplings from Mexico were brought in and planted at the corner of De La Vino and Canon Perdido. The first commercial orchard was planted in 1895 around the corner in Montecito by Kinton Stevens, who grew 120 trees.

The first successful commercial tree was the Fuerte. The Fuerte originated in Atlisco, Mexico, when Carl Schmidt brought back dozens of buds to the West Indian Nursery in Altadena, California. Each was marked, and after a major frost wiped out all the young avocados save for the tree numbered 15, the name Fuerte, for "strong" in Spanish, was applied. The tree became the dominant variety until 1972, when the Hass avocado overtook top production numbers.

In the 1930s, Charles J. Daily propagated forty varieties of avocados at his ranch in Camarillo. In 1939, he was presented the Outstanding Meritorious Service Award by the California Avocado Society. Among his grafts were the Cole Fuerte, the Carolyn and the Daily 11, an avocado that produces a two-pound fruit.

By 1950, there were twenty-five commercial varieties. The Fuerte accounted for two-thirds of the market.

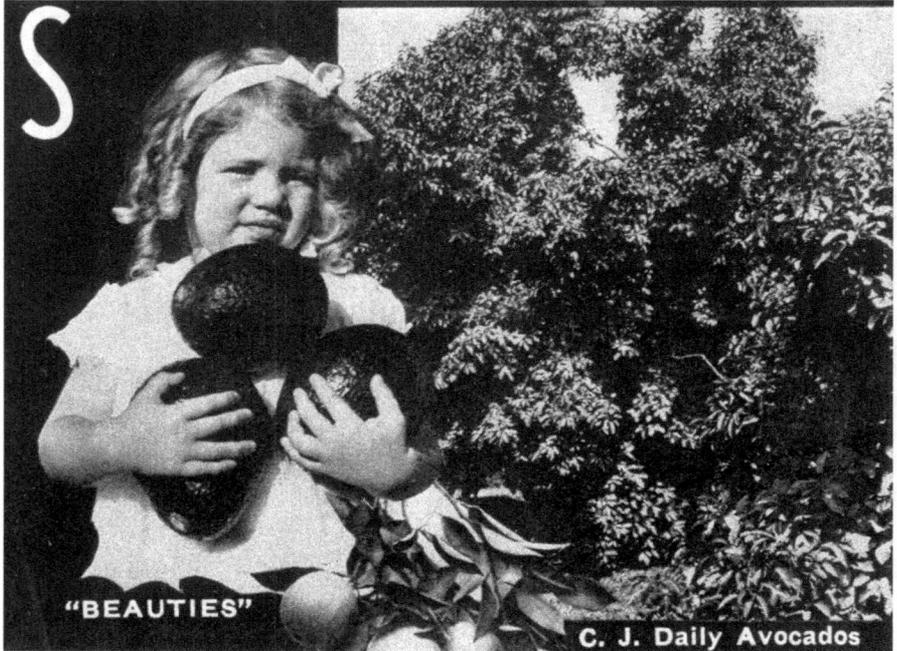

Carolyn Daily is pictured holding one of his grandfather Charles J. Daily's patented avocados. *Courtesy of Eric Daily.*

Rudolf Hass patented the Hass avocado in 1935 as a challenge to the Fuerte in later years. Hass was a mail carrier and amateur horticulturist. He bought three seeds of unknown origin from A.R. Rideout in 1926 and planted them to his one-and-a-half-acre grove in La Habra Heights, California. He tried grafting the strongest of the three with a Fuerte, but the graft didn't take. After deciding to cut down the tree, his children talked him out of it, and the tree survived seventy-six years before it was cut down in 2002. Soon after he patented the tree, he contacted Harold Brokaw, a nurseryman in Whittier, to grow and sell his grafted seedlings. Brokaw specialized in Hass, which has the benefit of producing year round and nets more fruit per tree, in addition to more oil content and a richer flavor.

Following in the footsteps of his uncle, Hank Brokaw planted five hundred avocado seedlings in his backyard in 1956. Fifty years later, with the nursery now located in Ventura, California, the Brokaw Nursery has sold more than ten million avocados worldwide.

Ventura County has two of the largest avocado-processing plants. The Calavo Growers was established in 1924 in Santa Paula, and Mission Produce

Mission Produce in Oxnard is the largest avocado packing house in the United States in 2016. *Thanks to Steve Barnard; author's collection.*

was founded in 1983 by Steve Barnard and Ed Williams. In 2014, Mission Produce built the largest and most technologically advanced packing facility in the United States. The plant was the largest in the world until a month after it was completed, when it built a larger facility in Peru.

A report by the Department of Agriculture from 1995 states that the first strawberries were planted in the county in 1929. By 1940, there were only 5 acres planted and only 11 acres by 1951. However, by 1961, there were 520 acres in crops, and the acreage grew to over 14,000 forty years later. California as a state produces 83 percent of the strawberries grown in the United States. Ventura County produces 27 percent of the state's output.

According to the Ventura County Farm Bureau website, the top crop of 2013 was strawberries, at $609 million in gross revenue, followed by avocados, at $210 million. There were still twenty thousand acres dedicated to avocados at this time and fifteen thousand to lemons, followed by fourteen thousand acres to strawberries. Farming and farm-dependent businesses provide forty-three thousand jobs, with an average of twenty thousand field workers. The 2014 report shows strawberries at up to $627 million, followed by lemons at $269 million and then raspberries, nursery crops, celery, avocados, tomatoes, peppers, cut flowers and kale.

The city's population has grown steadily. Before the factory, the closest town was Wynema (Hueneme) to the west and the small merchant and saloon corner known as New Jerusalem (El Rio) on the opposite side. The population of the Oxnard Plain was less than 500. In 1900, two years after the factory was built and the town site of Oxnard was established, the population was 1,200. A decade later, there were 2,555 people living in the Oxnard area.

Harry Watanabe and Richard Maulhardt with a strawberry harvest at the Maulhardt Ranch, circa 1960s. *Author's collection.*

By 1920, a few years after World War I, the population had reached 4,417. In 1939, the Port of Hueneme was established and offered the navy use of the port at the outset of World War II. In 1940, the population count was 8,519, and after the war, many decided to stay, increasing the population to 21,256. Another decade saw the population almost double, to 40,266. By 1980, 108,000 people made Oxnard their home, and within thirty years, by 2010, the population had doubled again to over 200,000.

While agriculture persists, the city has spread out to engulf many of the farms that became surrounded by urban sprawl. As generations passed on their lands, many families chose to cash out rather than take on the financial uncertainty of farming. Siblings had to decide if they wanted to band together to fight the weather, pests and encroaching neighbors or possibly lose the land to eminent domain. Most families made more money after selling their land than they did farming and paying for all of the expenses associated with it.

To preserve the lost history of Oxnard and its agriculture connections, I have been working to establish the Oxnard Historic Farm Park on land that

Right: The Oxnard Historic Farm Park is pictured here in March 2016 with the Gottfried Maulhardt winery in the background and the 1880 grapevines transplanted from Santa Cruz Island in the foreground. *Author's collection.*

Below: The Faria/Baptiste bean thresher started out on the Oxnard Plain before moving to the Baptiste Ranch north of Ventura and then returning to Oxnard as part of the display items at the Oxnard Historic Farm Park. Pictured is the group that coordinated the move from the Baptist Ranch in October 2013. *Author's collection.*

was first farmed by Gottfried and Sophie Maulhardt. The property was last farmed by Bob Pfeiler, and after he passed away in 2002, I began negotiating with developer John Laing Homes to carve out an acre of land around the 1870s home and winery with the addition of a two-acre city park around a portion of the perimeter. The property was designated as Ventura County Historical Landmark #165 and named the Gottfried Maulhardt/Albert Pfeiler Farm Site. In addition to collecting books and images for the Frank Naumann Local History Library, the Farm Park has collected valuable implements like a 1900s stationary bean thresher, a 1925 Buick Touring sedan, several refurbished tractors and multiple sub plows and seeders. The site has also brought back some of its roots by hosting an annual Oktoberfest on the first Sunday in October. The Master Gardeners of Ventura County joined forces with the Farm Park and created a Chumash Garden on the exterior of the site with interpretive signage to explain how each plant was used by the native people, in addition to planting lima beans and Oxnard's first cash crop: sugar beets.

NOTES

Chapter 1

1. Sheridan, *History of Ventura County*, 368.
2. Bank of A. Levy, *A. Levy*, 21.
3. Ibid., 47.

Chapter 2

4. Dennis, "History of the Beet Sugar Industry."
5. *Sugar Journal*, November 1962.
6. Ibid., 2.
7. United States Beet Sugar Association, *Silver Wedge*.
8. Ibid., 18.
9. Harris, *Sugar Beet in America*.
10. Dennis, "History of the Beet Sugar Industry."
11. Ibid.
12. United States Beet Sugar Association, *Silver Wedge*, 9.
13. Ibid., 23.
14. Ibid., 24.

CHAPTER 3

15. *PC, the Ventura County Weekly Magazine*, August 12, 1966.
16. Ibid.
17. E-mail correspondence, July 30, 2000.
18. *PC, the Ventura County Weekly Magazine*, August 12, 1966.
19. Oxnard, unpublished ms., ch. 2, 1.
20. Ibid., ch. 3, 1.
21. Ibid.
22. Ibid., 2.
23. *Press Courier*, June 28, 1983.
24. Gutleben, *Sugar Tramp*, 10.
25. Oxnard, unpublished ms., ch. 3, 3.

CHAPTER 4

26. Harris, *Sugar Beet in America*.
27. Gutleben, *Sugar Tramp*.
28. Ibid.
29. Ibid., 30.
30. Oxnard, unpublished ms., ch. 4, 10.
31. Strand and Hakala Communications Inc., *Heritage of Growth*, 27.
32. Ibid., 18.
33. Conversation with the author, August 31, 2000.
34. Strand and Hakala Communications Inc., *Heritage of Growth*, 20.
35. Adler and Feher, *Claus Spreckles*, 254.
36. Strand and Hakala Communications Inc., *Heritage of Growth*, 27.
37. Ibid., 29.
38. Oxnard, unpublished ms., ch. 4, 1.
39. Gutleben, *Sugar Tramp*, 8.

CHAPTER 5

40. Hutchinson, *Oil, Land and Politics*.
41. Ibid.
42. Ibid.
43. *Ventura County Historical Society Quarterly* (February 1966): 18.
44. *Ventura Independent*, October 8, 1896.

45. *Ventura Free Press*, October 22, 1897.

46. Greenland, *Port Hueneme.*

47. The $2 million price tag in 1898 translates into over $38 million one hundred years later, according to the inflation calculator www.westegs.com/inflation.

48. Guinn, *Historical and Biographical Record*, 503.

49. *Ventura Free Press*, October 22, 1897.

50. *Ventura County Historical Society Quarterly* 4, no. 2 (February 1959).

51. *Oxnard Courier*, July 25, 1948.

52. *Ventura Free Press*, November 5, 1897.

53. Deed Book 52, 587–90.

54. *Ventura Free Press*, September 10, 1897.

55. *Oxnard Daily Courier*, November 14, 1925.

56. Gutleben, *Sugar Tramp*, 53.

CHAPTER 6

57. *Oxnard Courier*, March 23, 1917.

58. Gutleben, *Sugar Tramp*, 54.

59. *Ventura Free Press*, December 10/, 1897.

60. Ibid., February 25, 1898.

61. *Oxnard Press-Courier*, September 24 and 25, 1948.

62. Roger B. Hatheway and Assoc., Oxnard Redevelopment Agency, January 1981.

63. Bank of A. Levy, *A. Levy*, 58.

64. Per conversation with the author, December 23, 1998.

65. *Los Angeles Times*, July 7, 1952.

66. *Oxnard Press Courier*, September 24, 1948.

67. Mervyn, *Tower in the Valley*, 36.

68. *Ventura County Historical Society Quarterly* 4, no. 2 (February 1959): 17.

69. Located at the Ventura County Museum of History and Art library.

CHAPTER 7

70. Cherie Brandt, "The Town that Sugar Built," *Reporter*, July 10, 1998.

71. Gutleben, *Sugar Tramp*, 4.

72. Ibid., 5.

73. *Oxnard Courier*, December 14, 1901.

74. *PC Weekly Magazine of Ventura County*, August 21, 1966.

75. *Oxnard Courier*, March 21, 1903.

CHAPTER 8

76. McWilliams, *Factories in the Field*, 106.

77. Fukuyama et al., "Citizens Apart."

78. Ibid.

79. McWilliams, *Factories in the Field*, 124.

80. *Oxnard Press-Courier*, September 24, 1948.

81. Ibid.

82. Ibid.

83. McWilliams, *Factories in the Field*, 106.

CHAPTER 9

84. *Oxnard Courier*, October 1958.

85. Ibid.

86. Ibid.

87. *Oxnard Daily Courier*, November 16, 1925.

BIBLIOGRAPHY

Adler, Jacob, and Joseph Feher. *Claus Spreckles: The Sugar King in Hawaii.* Honolulu: University Press of Hawaii, 1966.

Bank of A. Levy. *A. Levy: A History.* Virginia Beach, VA: Donning Co., 1991.

Bloom, Vera. "Oxnard: A Social History of the Early Years." *Ventura County Historical Society Quarterly* 4 (February 1956).

Dennis, Margaret Palmer. "History of the Beet Sugar Industry in California." Master's thesis. History Department, University of Southern California, September 1937.

Fukuyama, Yoshio, Helen Yamamoto, Mary Johnston and the Ventura County Historical Society. "Citizens Apart: A History of the Japanese in Ventura County." *Ventura County Historical Quarterly* 39, no. 4 (1994).

Greenland, Powell. *Port Hueneme: A History.* Oxnard, CA: Ventura County Maritime Museum, 1994.

Guinn, J.M. *Historical and Biographical Record of Southern California; Containing a History of Southern California from Its Earliest Settlement to the Opening Year of the Twentieth Century.* Chicago: Chapman Publishing Co., 1902.

Gutleben, Dan. *The Sugar Tramp, 1961*. Revised ed. Walnut Creek, CA, 1960.

Harris, F.S. *The Sugar Beet in America*. New York: Macmillan Co., 1919.

Hutchinson, W.H. *Oil, Land, and Politics: The California Career of Thomas Robert Bard*. Norman: University of Oklahoma Press, 1965.

McWilliams, Carey. *Factories in the Field: The Story of Migratory Farm Labor in California*. Boston: Little, Brown and Company, 1939.

Mervyn, Catherine. *A Tower in the Valley: The History of the Santa Clara Church*. N.p., 1986.

Oxnard, Benjamin, II. Unpublished ms., n.d.

Sheridan, Sol N. *History of Ventura County, California*. Vol. 1. Chicago: S.J. Clarke Publishing Co., 1926.

Strand, Paul, and Hakala Communications Inc. *A Heritage of Growth: American Crystal Sugar Company and the First Hundred Harvests*. St. Paul, MN: American Crystal Sugar Co., 1998.

United States Beet Sugar Association. *The Silver Wedge: The Sugar Beet in the United States*. Washington, D.C.: United States Beet Beet Sugar Association, 1936.

INDEX

ABOUT THE AUTHOR

*J*effrey Wayne Maulhardt was born in Oxnard and is a fifth-generation descendant of two of Oxnard's pioneer families, the Maulhardt and Borchard families. Jeff attended local schools and graduated from Hueneme High School, Ventura College and California University Chico, where he majored in philosophy and liberal studies.

Jeff taught in the Oxnard Elementary School District at a variety of grade levels before retiring as an eighth grade social studies teacher, where he taught American history at Robert J. Frank Intermediate School. Jeff also spent twenty years coaching basketball and softball.

For the past eighteen years, Jeff has dedicated himself to creating a history museum, the Oxnard Historic Farm Park, on an acre of land once farmed by his ancestors.

This is the fourteenth book Jeff has written, and all have dealt with local history.

Jeff is married to his high school sweetheart, Debbie, and they have twin daughters, Alison and Brooke.